Learn to Paint

BUILDINGS

Ray Evans

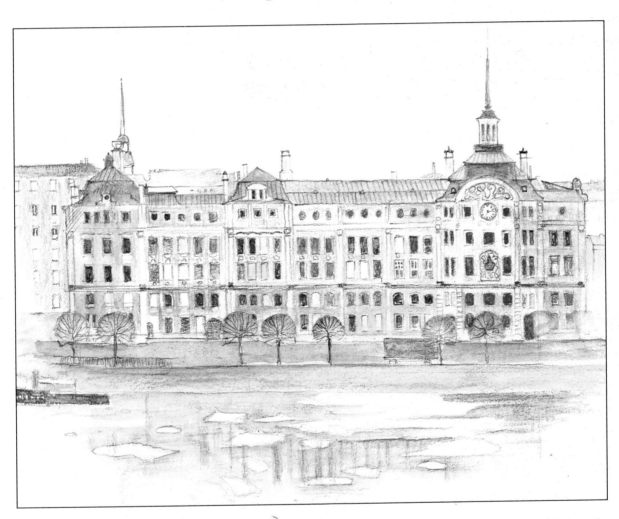

COLLINS

Acknowledgements
The author would like to thank Peter Bryan and Emma Davies
for lending their original paintings, and the Consumers Association
for the drawings from *The Good Hotel Guide*.

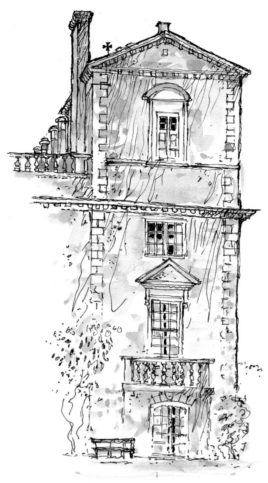

First published in 1987
by William Collins Sons & Co., Ltd
London · Glasgow · Sydney
Auckland · Toronto · Johannesburg

© Ray Evans 1987

Designed by Caroline Hill
Filmset by Ace Filmsetting Ltd, Frome, Somerset
Colour reproduction by Bright Arts, Hong Kong
Photography by Ben Bennett: pp. 1, 26, 27, 30, 31, 38,
39, 48, 50, 54, 55 (top), 59 (top), 61 (bottom left):
John Bigglestone: pp. 4, 5, 13, 15, 16;
Tony Latham: p. 40

British Library Cataloguing in Publication Data
Evans, Ray, *1920–*
 Learn to paint buildings—(Learn to Paint)
 1. Buildings in art 2. Painting
 I. Title II. Series
 751.4 ND1410

ISBN 0 00 411980 0

Printed and bound in Italy
by New Interlitho SpA, Milan

CONTENTS

Portrait of an artist 4
Ray Evans

Looking at buildings 6

What equipment do you need? 12

Perspective 18

Composition 22

Choosing a subject 28

Drawing 32

Keeping a sketchbook 36

Country buildings 42
Exercise one

Townscapes 48
Exercise two

Harbours and seaside 54
Exercise three

Details 60

House portraits 62

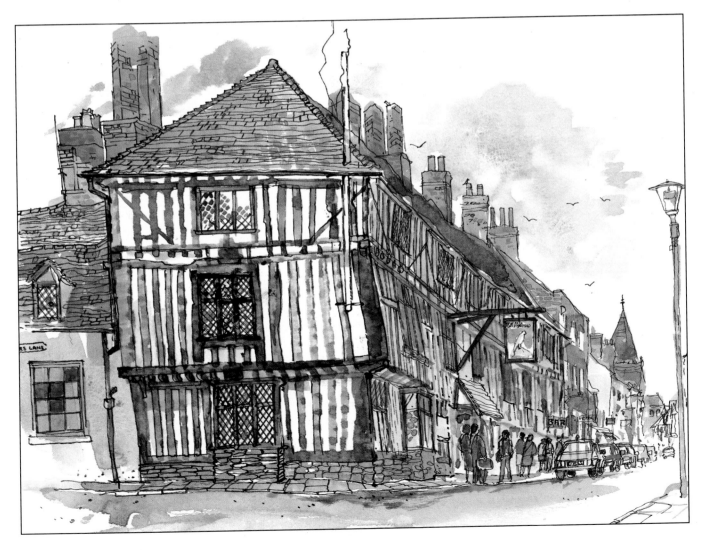

PORTRAIT OF AN ARTIST
RAY EVANS

Ray Evans sketching outdoors

Ray Evans has lived in the south of England for over thirty years but he never forgets his Welsh background. He now lives in Wiltshire and, as is usual for him, his studio is at the bottom of the garden. It has open rural views all round, yet the beautiful city of Salisbury is only three miles away.

Ray Evans started his career in an architects' office and for eighteen months learned something of the hard graft of architectural draughtsmanship. Then he served with the Army in a Survey Unit in North Africa and Italy, making a series of battlefield panoramas. When the war ended in Europe he was lucky enough to arrange two months, by courtesy of HM Government, in the Art Department of the Army Formation College; the Department was at the Istituto di Belle Arti in Florence. This lovely city and the numerous works of Donatello and Michelangelo there influenced him deeply. As a result, and encouraged by a contemporary Italian artist, he decided to go to art college when he returned to England. He studied for two years at Manchester College of Art and then for eighteen months at Heatherley's College of Art in London.

Since leaving art college in 1950 Ray Evans has worked freelance, with some part-time teaching and diversions into cartooning, magazine and book illustrating. He no longer teaches, however, as he is now far too involved in painting commissions and in illustrating. Over the last five years or so he has been commissioned to paint several series of large watercolours, mainly of architectural subjects, for the boardrooms of a variety of big firms and organizations. Recently two paintings were commissioned and

Ray Evans working in his studio

presented to a member of the Royal Family and to the Minister of the Environment. He has illustrated books for several publishers and regularly illustrates guide books for the Consumers Association. He has also produced several calendars as well as a number of limited edition prints.

Ray Evans was elected a member of the Royal Institute of Painters in Watercolours in 1966 and a Fellow of the Society of Architectural Illustrators in 1978. He is currently a Council Member of the former and was until recently the Exhibition Secretary.

He is a compulsive traveller and has travelled all over Europe, in parts of Asia and North Africa, and in the Far East. He has visited the USA twice, and in 1984 was invited to tour American universities, lecturing and demonstrating techniques of sketching in watercolours and in freehand drawing, as well as giving public slide lectures. Recently he visited Moscow, Leningrad and Kiev and made a number of impressive architectural drawings and watercolours while he was there.

Ray Evans has never lost his original interest in architecture, and his paintings, articles and books often reflect this. He still claims that his greatest pleasure is with the sketchbook, making preliminary watercolours, sketches and notes on the spot for the many large watercolours he paints, or using a sketchbook for pleasure and interest while travelling. His most recent book, *A Pocket Guide to Sketching*, concentrates on these aspects of drawing. He has also written two other books, *Travelling with a Sketchbook* and *Drawing and Painting Buildings*.

LOOKING AT BUILDINGS

Of all the subjects to draw and paint, I find that architecture is the most fascinating and satisfying. All buildings have a history and a story to tell, and learning how to draw and sketch them enables you to read that story more easily. The older the building, of course, the longer the story. It is my intention in this book to try to help you to understand what you see, to learn about buildings, and eventually to become skilful in putting that knowledge on paper in the form of drawings, sketches and finished studies of architecture.

It is always a good idea to look at the way other artists, past and present, have painted buildings. Go to museums and art galleries and become more critical of what you see. There are countless ways of expressing yourself and drawing architecture too mechanically can be as unsatisfactory as a careless approach. You have only to look at the drawings and watercolours of buildings by an artist such as J. M. W. Turner to see how freedom of expression can be successfully linked with an underlying deep knowledge of the structure of a building. It was this skill, developed early in his youth by making detailed studies of architecture, that

enabled Turner to make such imaginative and creative sketches and paintings in his later years.

One of the first things you must realize, therefore, is that if you wish to make a success of drawing and painting architecture, it is necessary for you to study and acquire a basic knowledge of the subject. It is just as important to have some knowledge of building structures and styles as it is for an artist to have some acquaintance with anatomy when drawing the figure. You will, I believe, become more and more interested in these aspects as you progress. Remember that drawing is an intellectual process and you should not just copy without thinking. Attention to detail makes a better whole. Often success depends on drawing a combination of what is known as well as what is seen.

It is not, however, my intention to go into the realms of building construction here – this is dealt with more fully in my book *Drawing and Painting Buildings* – nor do you need to become an architect! I do ask you, though, to look very carefully at the buildings you are drawing and painting. Wherever you live you should notice how buildings differ and how styles and building methods have changed over the years. Endeavour to

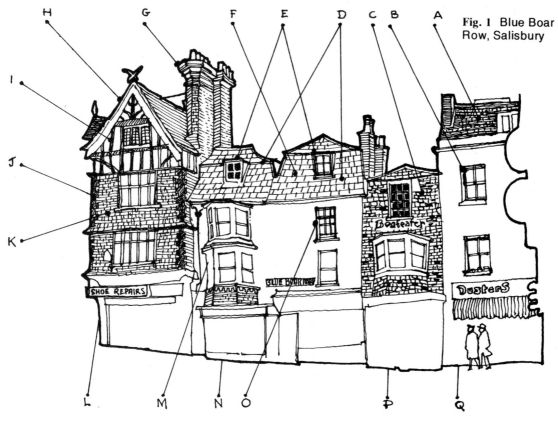

Fig. 1 Blue Boar Row, Salisbury

A Tiled clay roof
B Recessed sash window
C Tile-hung wall
D Gambrel roof (double pitch)
E Dormer windows with flat lead roofs, built wholly into the roof space
F Slate roof
G Heavily moulded, oversailing brick courses
H Gable dormer roof; window above eaves with barge boards (weather protection)
I Half timbering (Victorian)
J Quoins
K Tile-hung wall – overhangs for weather protection
L 4-storey house
M Bay windows
N 3½-storey house
O Top sash window
P 3-storey house
Q 3½-storey house

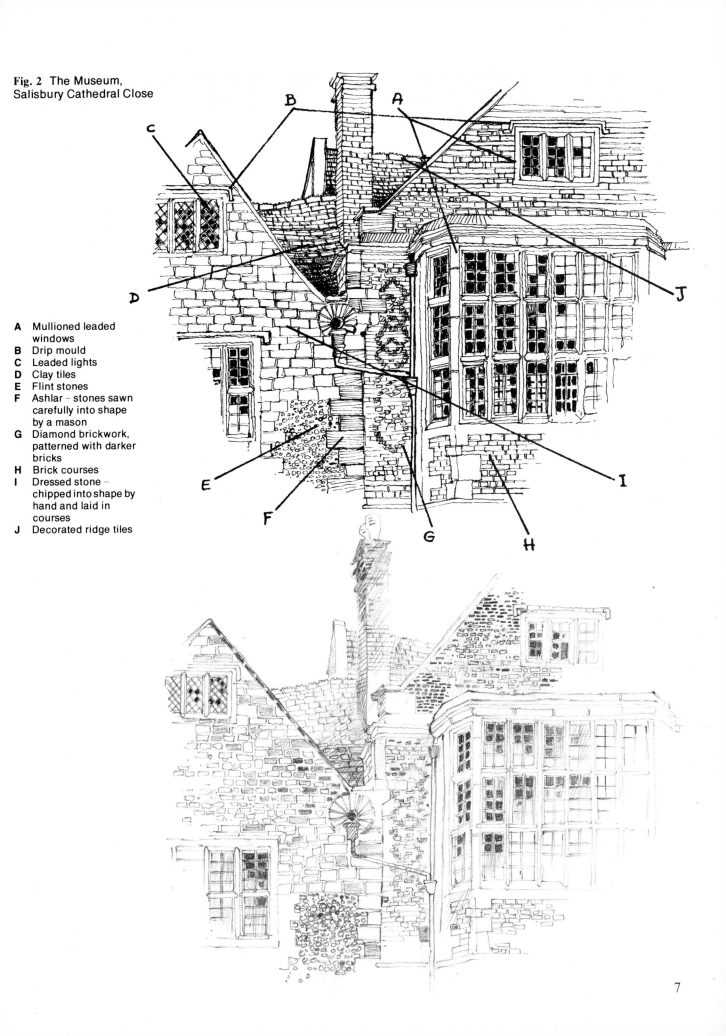

Fig. 2 The Museum,
Salisbury Cathedral Close

A Mullioned leaded
windows
B Drip mould
C Leaded lights
D Clay tiles
E Flint stones
F Ashlar – stones sawn
carefully into shape
by a mason
G Diamond brickwork,
patterned with darker
bricks
H Brick courses
I Dressed stone –
chipped into shape by
hand and laid in
courses
J Decorated ridge tiles

7

read the age of the building by studying its character and the way in which it has aged; see whether it has been altered or rebuilt, or has bricked-up doors or windows; whether it has been strengthened with tie bars or protected in some other way. Whatever building you look at, note, for example, the brickwork or stonework and how it is laid in courses; understand what the walls are constructed of: stone, brick, flint, wood or slate; look at the roof: the materials used differ from county to county in Britain, except for the ubiquitous concrete. Features such as baroque gable ends, for example, which are found in the Low Countries and are echoed in East Anglia, are very decorative. In **figs. 1** and **2** I have tried to indicate the basic construction of the buildings by labelling their principal parts. These are the main features you should look for. You will see how the style of buildings is determined by different methods of construction. A word of warning here: at first glance the appearance of some older buildings may be misleading for many have false fronts, perhaps brick or plaster over original half timbering. Some 'Georgian' houses, for example, are in fact medieval behind the façade. As your experience increases, however, you will be able to recognize such cases.

Pure academic knowledge is not enough, however: you must learn by drawing. Since every line in a building has a function, if you do not understand what you are looking at, then you surely cannot draw it convincingly. You must go up to the building and look closely if you do not understand any of its architectural construction. Always carry a sketchbook, however small, with you wherever you go: the knowledge collected in a travelling sketchbook can be immense. Do not be too concerned about the technical names of the parts of the building you sketch: this knowledge will accumulate in time. Concentrate on getting the drawing proportions and details basically right, how-

ever quick and lively your painting may be. Remember, too, to look at your subject properly for only then will you be able to portray it accurately. For example, windows and doors are the expression on the face of a house, and if a window is recessed into the depth of the wall this must be shown, otherwise you will not capture the character of the house. In addition, it should be clear whether a window is a sash or a casement. These may seem small details, but if shown correctly, even though sketchily, they will give your drawing authenticity and conviction. There really is no excuse for a sloppy or careless drawing.

For the watercolour of the skyline of Ypres in Belgium (**fig. 3**) I used a Saunders A3 sketchpad containing mould-made pure rag paper with a Not surface (90 lb). I set up my sketching stool on the battlements above the Menin Gate and made a careful drawing using a B and an HB pencil. This took the best part of 2 hours. I then added the first colour wash, applying it over the spires and towers in the background. I used a warm grey mixed from French Ultramarine, Black and Crimson Alizarin, and washed and blotted out as necessary. For the middle- and foreground I used washes of Crimson Alizarin, Burnt Sienna, Yellow Ochre and a little Black, again washing out and blotting. The day was very warm and rather hazy and to achieve this effect I decided to leave the sky in my painting white. In fact, the only strong darks are in the foreground windows. It was important to let the tone values reveal the distance between the towers and spires and the foreground buildings. The detail on the towers and spires was put in with a pencil and a fine brush.

When I returned to England I removed the paper from the sketchpad and stretched it on a board by wetting both sides with a large brush and pasting down the edges with 51 mm (2 in) wide gum strip

Fig. 3

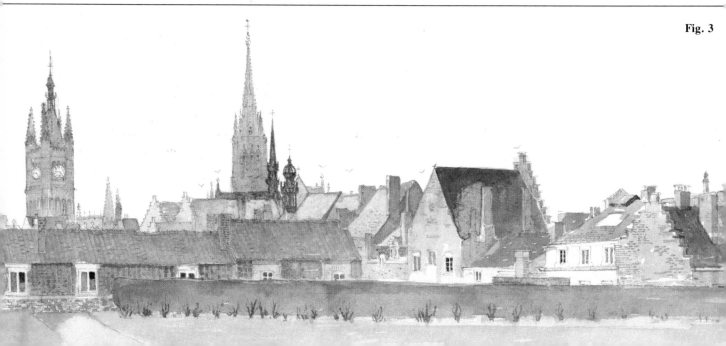

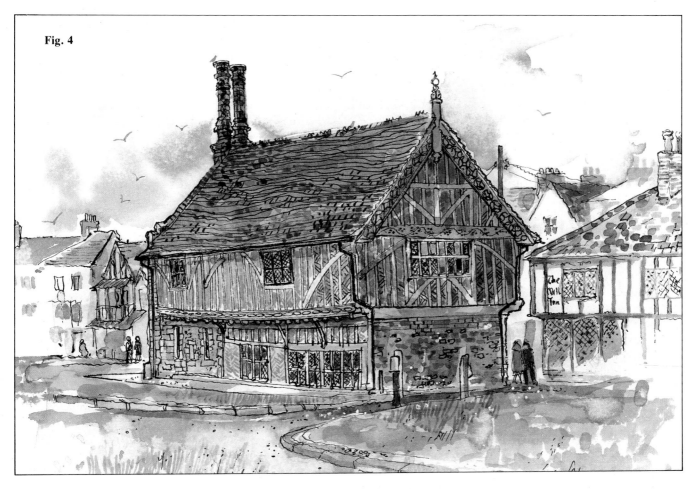

Fig. 4

paper. I often do this with larger sketches; if you are careful you will find that the colour will not wash off. My reason for doing this was that I wished to wash in a stronger colour over the foreground hedge and work on the details a little more.

The watercolour of Moot Hall, Aldeburgh (**fig. 4**), was sketched in about 1½ hours and measures 216 × 140 mm (8½ × 5½ in). I worked on a pad placed on my knee and used a small watercolour box containing six colours: Prussian Blue, Crimson Alizarin, Rose Doré, Ivory Black, Olive Green, Raw Sienna and a small amount of Chinese White.

I began drawing in colour only, concentrating on the shape of the buildings, applying light washes and leaving white paper where necessary. I used a Diana Kolinsky No. 2 brush and a No. 6 for larger areas of colour. Always remember that the beginning of your drawing or painting is the most important part.

When the painting was half finished I drew in the details with a 0.25 technical pen as freely and quickly as accuracy allowed. If you look at the right-hand buildings in particular you can see that the pen was used sparingly. As from time to time the Hall was in shadow, I decided to make it darker, leaving the background lighter. I put a wash of Prussian Blue and a little Ivory Black over the building, using a Dalon

D.88 13 mm (½ in) wash brush. The wash went partly over the foreground as well.

When the sketch was half dry I brushed over it with water – some colour came away, leaving an interesting texture. This operation must be timed carefully, not too soon or too late. With experience you will be able to judge the right moment. A few spots of Chinese White enlivened the darker areas. This effect can also be achieved by flicking a sharp blade over the dark surface. The figures give the building scale; it is often advisable to put them into your paintings for this reason.

Certain interesting architectural features are apparent in this picture. The building is a box-framed construction of jointed timbers with an infilling of bricks laid in a herringbone pattern. It is of the early seventeenth century, the decorated chimneys typical of this period with their scalloped, oversailing, heavily moulded brick courses. Note the finial above the gable end and the decorated carved barge boards (see **fig. 1**). The overhung first floor is interesting, too: this is referred to as jettied construction.

If you are drawing an important building and you wish to know more about it, try finding some local guides or pamphlets. You can then make notes on your drawing as I have done in **fig. 76**.

ARCHITECTURAL STYLES

Fig. 5

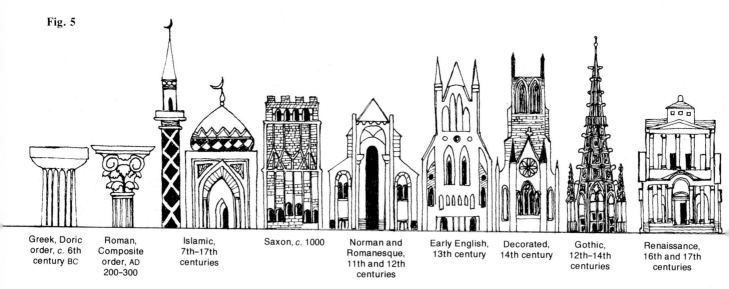

Greek, Doric order, *c.* 6th century BC

Roman, Composite order, AD 200-300

Islamic, 7th–17th centuries

Saxon, *c.* 1000

Norman and Romanesque, 11th and 12th centuries

Early English, 13th century

Decorated, 14th century

Gothic, 12th–14th centuries

Renaissance, 16th and 17th centuries

These two pages provide a miniature guide to the history of architecture. The drawings are not to scale and the dates are only approximate, since architectural periods are rather arbitrary and often overlap. The sketches represent generalizations of building types and are intended merely to stimulate and encourage you to take your studies and interest further in this direction. By becoming more aware of the history of buildings as well as of their construction, you will be able to translate what you see into more effective drawings and paintings.

I have always been fascinated by skylines; when one looks at a distant city or town the skyline is the most notable feature. **Fig. 5** illustrates some simple drawings of buildings of all periods and from various countries, and demonstrates how interesting a skyline can be.

Fig. 6 illustrates some of the major architectural styles. It starts with the early cruck houses, which were thatched with straw or reeds and were used to house animals as well as people. They kept to the tent-like form used since the days of early man. The box-framed house was also a simple wooden construction, infilled at first with wattle and daub and later brick and plaster. The more sophisticated that building became over the years, the more it harked back to the classical styles of Greece and Rome, although, of course, the

Fig. 6

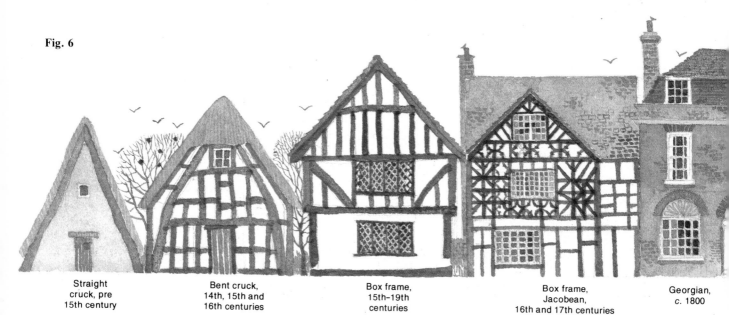

Straight cruck, pre 15th century

Bent cruck, 14th, 15th and 16th centuries

Box frame, 15th–19th centuries

Box frame, Jacobean, 16th and 17th centuries

Georgian, *c.* 1800

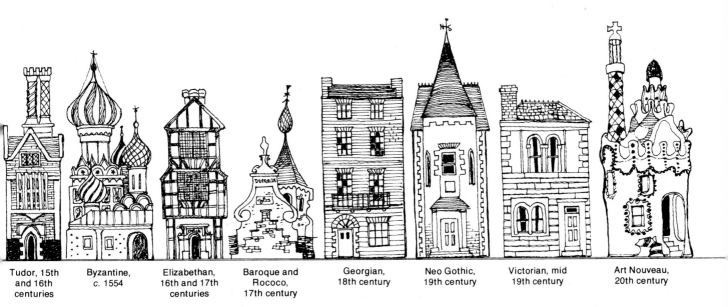

Tudor, 15th and 16th centuries Byzantine, c. 1554 Elizabethan, 16th and 17th centuries Baroque and Rococo, 17th century Georgian, 18th century Neo Gothic, 19th century Victorian, mid 19th century Art Nouveau, 20th century

introduction of new techniques, such as the ability to make larger sheets of glass, and the invention of materials such as concrete and steel brought about great changes. But above all it was the imagination of the architects and the skill of the builders that were responsible for the great heritage we now possess.

It is beyond the scope of these two pages to do more than touch on this vast subject. I can but mention the great Egyptian architecture of the centuries before Christ, and that of China, Japan, and other Far Eastern countries; and the buildings of eighteenth- and nineteenth-century America, where much of the early east-coast architecture, from New England down to South Carolina, is an echo of Georgian and Regency architecture in Britain. Many of these buildings, in towns like Salem in Massachusetts and Charleston in South Carolina, are very beautiful. To describe the architecture of the great modern cities of Chicago and New York, where the true skyscrapers were born, would take another two pages. Elsewhere in this book, however, I have drawn and painted some architecture from America and other parts of the world, such as Russia. My recent trip there opened my eyes to yet another wonderfully preserved heritage. What is shown here, I hope, is enough to whet your appetite for learning more about this fascinating subject.

Regency, 19th century Neo Gothic, 19th century Victorian, mid 19th century Modern, 20th century

WHAT EQUIPMENT DO YOU NEED?

An artist's equipment requirements depend, to some extent, on whether he is sketching or painting outdoors or working at home in the studio.

Materials for working outdoors

I believe that sketching and painting in the field is the most important of the two; it is while we are working outdoors that we gain knowledge, information and inspiration for any work we do later indoors. Generally, you will need to limit the amount of equipment you take out with you, but certain items are essential. You probably won't need an easel in the winter months, for example, but a stool or seat is advisable. I use a collapsible nylon one on a light aluminium frame which folds into a walking stick. It is slightly cumbersome but light to carry and comfortable to sit on and I can work easily with my sketchbook or board on my knee. It is important, although not always possible, to be comfortable in order to put all your energy into your work. Seats of this type can be bought at sport or fishing equipment shops.

I have used numerous bags over the years to carry essential equipment. It is most important to choose one with several pockets to isolate various items. The bag should open up well and be able to carry a good-sized sketchbook. For work in cities and while travelling, I use a stiff case somewhat like a businessman's briefcase, which is ideal because everything in it can be seen and found easily (see **fig. 7**). It measures about 457 × 355 mm (18 × 14 in) and has a hard top which I can work on. Inside the lid is a pocket for pens and another for smaller sketchbooks. I carry a number of watercolour pencils, four or five brushes and pencils in a tube brush holder, a small watercolour box and water pot wrapped in cloth, ink, nibs, etc., in a box, clips for holding down paper in windy weather, a knife, small eraser and, in the bottom of the case, a larger sketchbook and blotting paper. I also take with me three or four architect's drawing pens (sizes 0.18, 0.25, 0.35 and 0.70) and, in case I am in a settled position with plenty of time, a quill pen and Indian ink. A small automatic camera completes this travelling and working equipment. This is used as an aid when time is restricted or for taking photographs of different angles of the subject which can be helpful when working on a larger studio painting. These photographs may contribute to your comprehension of the building but they should not be used solely for the purpose of copying because the camera distorts the image. Always base your paintings on your sketches, for it is the information in them which gives life, freshness and enthusiasm to the finished works.

Watercolours and brushes For sketching I favour Daler-Rowney's small watercolour box with an integral water pot (No. 12B). I often make drawings and sketches of buildings for commissions in London and this box is very handy. It contains twelve colours: Cadmium Yellow Pale, Cadmium Red, Scarlet Alizarin, Crimson Alizarin, Viridian, Burnt Umber, Yellow Ochre, Burnt Sienna, Light Red, French Ultramarine, Prussian Blue and Ivory Black. These colours are quite adequate and you could in fact use only four to six of them; but remember that buildings come in many colours and you will need to be able to portray warm sandstone or Mediterranean golds and terracottas as well as the cool greys of Wales or Cornwall, for example.

This box also contains a single brush which might be sufficient for a quick note done standing up, but I prefer to carry a fine Diana Kolinsky No. 1 brush, as well as a No. 5 or 6 and a larger wash brush – perhaps a No. 10 or a square-ended brush from the Dalon D.88 series, which is fine for architectural work. The Diana Kolinsky sable brushes are the best, I find, or the pure sable Series 133 or ox-sable Series 55 brushes, all made by Daler-Rowney. The Dalon D.77 synthetic brushes are also excellent and, of course, less expensive.

Pens and pencils Joseph Gillott nibs, particularly Nos. 170, 290, 291 and 303, used with the No. 52 penholder, are excellent for architectural drawing. Daler-Rowney Kandahar inks, which are waterproof and come in a variety of colours, are very good; I tend to use black, sepia and brown only. If you are using black it is more economical to buy the 150 ml bottle and keep it in the studio. Architects' or designers' drawing pens (stylos), such as those by Pentel, Rotring, Faber-Castell and Staedtler, are good. Use their own standard inks and keep one pen just for brown ink. You can also use felt-tipped pens, by Pilot, Edding, Pygma and Stabilo, which are water-based and again available in several colours. Ball-point pens, by Parker, Pilot and many other manufacturers, are useful, too. Use them with black ink, however, not blue. If you want to use fountain pens, choose a good make, such as Parker or Rotring. You should always use a fine nib and black ink specially for fountain pens (which is not waterproof).

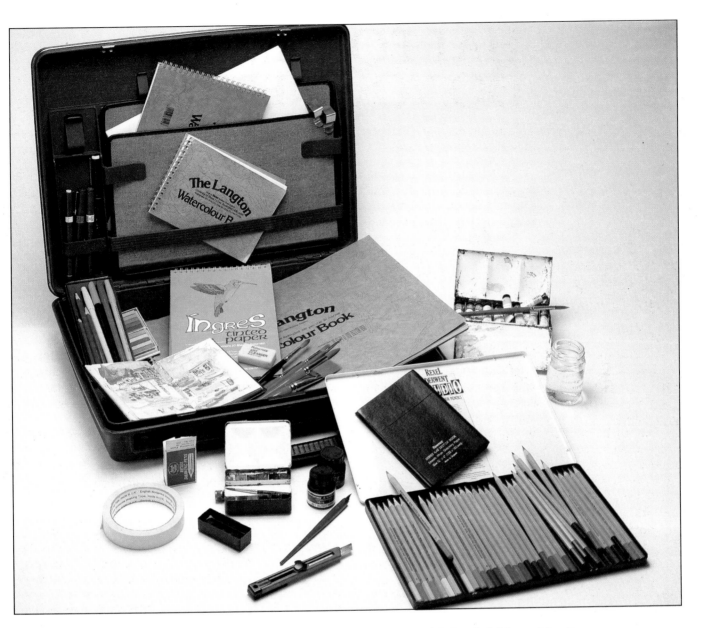

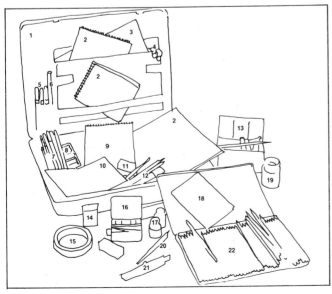

Fig. 7 Materials for sketching outdoors

1 Briefcase
2 Langton watercolour pads
3 Blotting paper
4 Clips
5 Technical pens
6 Rotring art pen
7 Pencils and felt-tipped pens
8 Oil pastels
9 Ingres tinted paper
10 Pocket sketchbook
11 Daler-Rowney cleansing eraser
12 Watercolour brushes
13 Watercolour box
14 Gillott drawing nibs
15 Masking tape
16 Small watercolour box with integral water container
17 Rexel drawing inks
18 Daler-Rowney pocket sketchbook
19 Water pot
20 Dip pen
21 Knife
22 Rexel Derwent watercolour pencils

There is a very wide range of pencils available. I prefer to draw with a hexagonal pencil, such as Daler-Rowney's No. 820A, and I use the softer leads – B, 2B and sometimes 4B. Victoria coloured pencils, also supplied by Daler-Rowney, are excellent, and Derwent and Berol Prismacolour coloured pencils are good, too. Always remember to keep your pencils and crayons sharpened to a long point with a knife.

Sketchbooks and paper I cannot emphasize enough that the first sketchbook you should buy is a small pocket book which you should learn to carry with you always. There are many suitable small books on the market, such as the Daler-Rowney size A6 pad, which measures 292×229 mm (6×4 in). The most practical sketchbook for watercolours and pen and wash drawings is the Langton watercolour book, which contains Bockingford 140 lb paper. This is stiff enough not to cockle even in the largest size (508×406 mm/20×16 in). Two other sizes (355×254 mm/14×10 in and 406×305 mm/16×12 in) are very practical too, but there are smaller sizes as well and the 178×127 mm (7×5 in) one in particular is excellent for quick studies.

Ingres tinted paper supplied by Daler-Rowney can be bought in varying-sized pads. These are good for gouache, watercolour and pen, but they will cockle somewhat. Separate sheets can also be bought and stretched. Daler-Rowney Drawing Books with double-sided Ivorex board are ideal for pen and ink or pencil, and they will take watercolour, too. I like to have my own sketchbooks made up by a bookbinder, using offcuts of different sorts of paper, including even brown wrapping paper, which is excellent for pen drawings with Chinese White highlights. These books are a luxury, of course, so recently I joined a bookbinding class so that I could learn to bind my own! I thoroughly recommend this very satisfying, useful and enjoyable craft.

When working on large watercolours outside and using an easel, I stretch good watercolour paper, such as Bockingford or Waterford, on a light but strong plywood board. If you want to do this, wet your paper on both sides and stick it down all round with 51 mm (2 in) wide gum strip paper. Allow the paper to dry in the studio or house, but not in sunlight.

The equipment described so far is what I regard as the minimum required. However, in bad weather and in the winter I sometimes use my car as an extension of the studio and can therefore take more equipment with me. Then I take a watercolour box like the Daler-Rowney WT10C, fitted with tubes of colour of my own choice, such as Raw Sienna, Prussian Blue, Burnt Sienna, Brown Madder Alizarin, Cadmium Red, Permanent Sepia, Rose Doré, Cadmium Yellow, Ivory Black, and a tube of gouache white (or Chinese White).

Rarely do I use more than six of these at a time, however, and sometimes less. Also, with the coming of spring, out comes the easel. I use a small lightweight one such as the Daler-Rowney 'Warwick'. This is made of aluminium and can be adjusted for watercolours to a standing or seated position.

Materials for working in the studio

All the materials used for sketching, described above, are of course also part of the equipment you will need in your studio, but there are some additional items you might require (see **fig. 8**). For example, it is ideal to have a supply of larger Imperial sheets of watercolour paper (762×559 mm/30×22 in), either Hot Pressed, Not or Rough and of a weight you like working on. Hot Pressed paper has a smooth surface; Not has a slightly rougher surface; and Rough has more texture still. I tend to use Not and Rough surface papers most often, usually 140 lb. The Saunders Waterford Series papers are ideal. I prefer to use not too heavy a paper but to stretch these papers for studio and larger outdoor work.

I am the proud possessor of a Daler-Rowney watercolour box which is a replica of their original box made in 1795. With its fine wooden box and china palette, it is ideal for studio work. A suitable box for a beginner might be Daler-Rowney's WT10CW or their WP12CW, which can be fitted with colours of the artist's own choice. Daler-Rowney supply cabinet nests of five china palettes and also china slant slabs. Personally I prefer these to plastic trays or pots, which somehow do not feel right; they are too light and difficult to clean. Old china saucers are better.

Daler-Rowney's Cryla Acrylic Colours are brilliant and exciting to work with. For architectural studies I like to use them thinly like watercolours. They produce entirely different effects from traditional watercolours during washing-out procedures. Acrylic Gloss Medium is useful with these colours and can also be used with watercolours. Designers' Gouache Colour is a fine medium to use, particularly for flat, opaque colour washes for illustration and book jacket design.

It's important to have some means of storing your brushes and other drawing implements. I have a number of plastic containers and dispensers (readily available from kitchen departments in stores), some of which have several useful sections suitable for holding brushes, pens, pencils, knives, etc. Brushes can be upended either in ordinary jars or in a wooden block with holes of various sizes drilled in it.

Other items which you might find useful to have in your studio are a mount cutter, a heavy steel ruler and strawboards for cutting on; a large T-square and set square, both plastic and transparent, for setting up architectural perspectives or studies; a plastic ruler

marked with inches and millimetres; and also a good supply of blotting paper.

You should try to ensure that your studio conditions are suitable to work in. Even if you have only a corner of a room a nice amount of space can be organized. You will need to have plenty of working top space so that if necessary you can keep more than one subject going at the same time. I use part of my working top primarily for cutting mounts – it is higher than the rest to enable me to work standing up. A large table is a great help and, of course, you will need several drawing boards. I keep a number of lengths of 76 × 51 mm

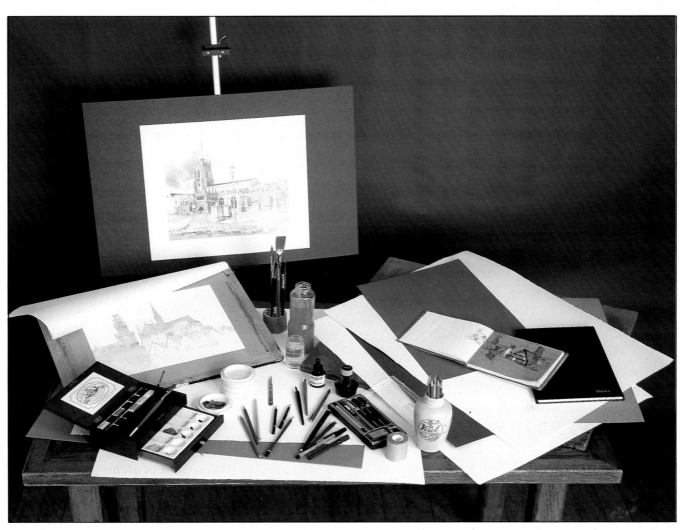

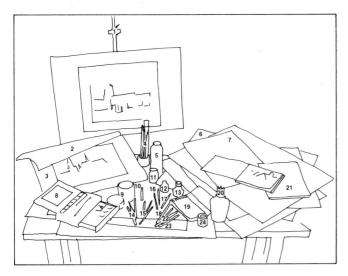

Fig. 8 Materials for working in the studio

1 Aluminium easel
2 Masking film
3 Gum strip
4 Watercolour brushes
5 Water for cleaning brushes
6 Drawing board (with wood block underneath to slant it)
7 Papers
8 Daler-Rowney replica watercolour box with brushes
9 Stacking ceramic palettes
10 Scalpel
11 Fresh water
12 Indian ink
13 Fountain pen ink
14 Victoria coloured pencils
15 Lead pencils
16 Dip pens
17 Fountain pen
18 Art pen
19 Technical pens
20 Victoria coloured pencils
21 Daler-Rowney sketchbook
22 Felt-tipped pens
23 Pentel ceramic pen
24 Gum strip

Ray Evans's photo album and camera

$(3 \times 2 \text{ in})$ wood blocks which I use to adjust the height of my drawing boards as required. There should be plenty of cabinets and shelves in your studio for equipment and reference books. Correct lighting is very important, too. You must have a large window to give plenty of daylight on your working space, and additional light can be provided in the form of overhead spotlights and an adjustable table lamp with a magnifier attached.

Using mixed media

Almost anything that makes a mark can be used for painting and drawing: watercolours, gouache, Chinese White, acrylics, pen and ink, oil pastels, crayons, watercolour pencils, felt- and fibre-tipped pens, masking fluid and tape, masking film and varnish. You may decide to acquire some or all of these media, depending on what appeals to you. You may also choose to use two or more of them together because some interesting effects can be created in this way. A note of caution, however: some media don't mix well – for example,

oils and watercolour. Be careful, too, when using gouache in mixed media work for if it is put on paper too thickly it will crack and flake off when dry. However, this can be avoided by adding some Acrylising Medium to it to render it water-resistant and flexible. **Fig. 9**, which shows Haworth Parsonage, the home of the Brontë family from 1820 to 1861, was sketched in an hour and demonstrates how ink and oil crayon can work very well together.

The use of some of these media as masking agents demands special techniques, which it might be helpful to explain here while you are considering what equipment to obtain. If your initial drawing is of a fairly detailed architectural subject, for example, masking film can be cut and used rather like a stencil. By placing this low-tack, soft-peel film over your drawing, you can cut out with a very sharp pointed knife whatever areas you wish to be coloured – but be careful not to penetrate the film's backing sheet. This cutting demands patience; you are actually drawing with a knife. When you have cut out all the sections of film you require, remove them from the backing sheet. This will

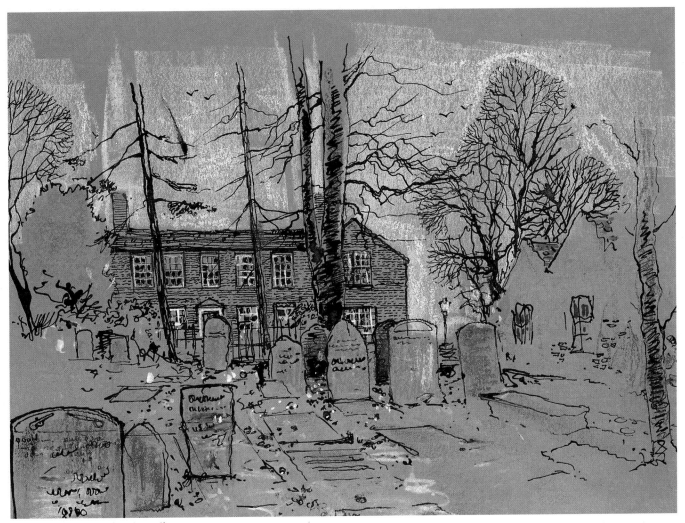

Fig. 9 Sketch in mixed media

leave you with a template. Remove the backing sheet next and place the film over your drawing. Then, using a large 51 mm (2 in) brush (or if necessary a smaller one for details), wash watercolour or acrylic washes over the drawing. Some colour may escape under the template, but do not worry about this too much. When the colour has stained enough and is nearly dry – with experience and experiment you will be able to judge this – remove the template and immediately wash out by pouring clean water over your board. If too much colour remains in places, gently use a large wash brush to wash out further or add texture. You will now have a textured pattern of your building on the paper and a very good basis for making further washes and painting in details. The results of this technique are, often fascinating and the process is rewarding and enjoyable, too. I find that a Not textured paper gives better effects – I usually use a sheet of stretched Saunders 140 lb Not.

You can also use masking tape to make templates, but if you do this be careful to warm the tape over a heater prior to removing it or it will take some of the paper's surface with it. Other media can be used to mask parts of your painting. Crayons, candle wax and oil pastels will act as a resist and acrylic varnish can also be used, although this should be diluted with water or it can leave an unpleasant and irremovable surface. I find masking fluid rather unsatisfactory over large areas and it often leaves untidy edges; but applied in lines with an architect's ruling pen it is fine for putting in details such as telegraph wires or fencing. Again make sure that it is warmed before removal.

Apart from masking, other effects can be created by using a combination of media. For example, blotting paper pressed lightly over a wash or half-dry water-colour will give interesting results, but do not overdo this procedure because by repeating too many washes you will lose transparency. Gouache white (or other appropriate light colour) can be useful if you find you have made a mistake. Mixed with diluted acrylic gloss varnish, it can be used to touch up the area in question; the mistake may be rectified and an appearance of transparency recovered.

PERSPECTIVE

Perspective is not a word to be frightened of. It is a technical name for a natural phenomenon which is based on two indisputable facts: that objects of the same size appear to grow smaller the further away they are; and that the horizon, or true horizon, which is also the eye level, always remains static.

When you are seated in front of your subject, try the following experiment. Hold a ruler level with your eyes at arm's length, then move it up and down, *keeping it parallel* to your eye level. You will see that all the lines of the roofs, doors and windows appear to slope upwards or downwards towards the horizon. Alternatively, draw a grid on your paper in light pencil and fill in the gridded paper section by section. This will enable you to see which lines go down to the horizon and which go up.

Fig. 10 illustrates single-point perspective. If you look down a straight street where the houses are parallel to each other, you will notice that the lines of the windows, doors, gutters and other street furniture vanish at the horizon at the end of the street (the vanishing point: VP). Old houses will inevitably droop

and windows will not be level, but this will be taken into consideration as the perspective lines are only imaginary. The ruler method will indicate the correct angles. In **fig. 11**, illustrating two-point perspective, the houses are at an angle but parallel to each other. By standing opposite the corner of a building such as shown here, you will see that one side of the building has a vanishing point to the left (VP1) and the other side has a vanishing point to the right (VP2). Remember that buildings will always appear smaller the further away they are.

Once you have understood and mastered these basic rules, look at **fig. 12**, which shows a more complicated situation. Here the building in the second colour is taller than the others and at a different angle, so it has two different vanishing points. In **fig. 13**, which illustrates how to draw an arch, note the diagonal lines joining the corners. Where they intersect a line is dropped vertically to find the centre of the arch in perspective. The mother and child give scale to the arch in the same way as the windows, door and man do in **fig. 10**.

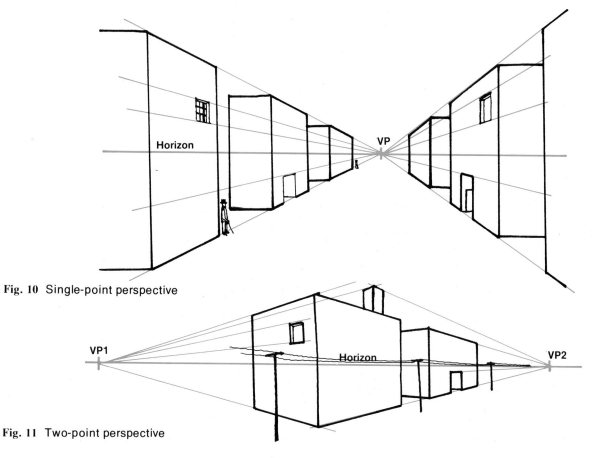

Fig. 10 Single-point perspective

Fig. 11 Two-point perspective

Fig. 14, drawn in Stratford-upon-Avon, illustrates an obvious example of one-point perspective; the other vanishing point on the left would be far away, near infinity, since I was sitting looking almost square-on to the end of the main building when I drew this. Notice that even the cars and people are on a vanishing line. The lamp post is necessary here as a means of drawing the eye back into the picture. The finished watercolour of this subject, based on the drawing here, is illustrated on page 3.

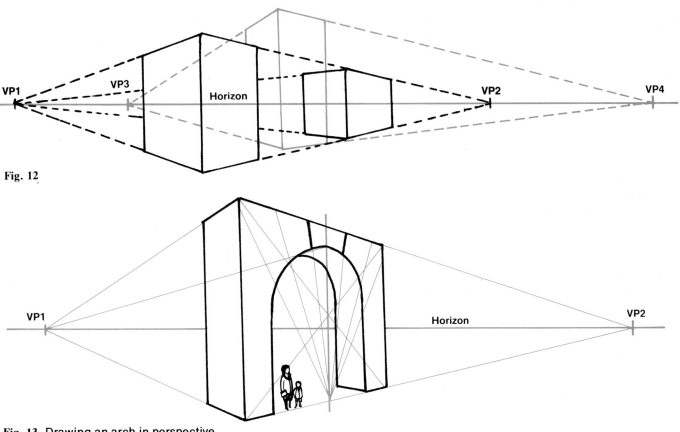

Fig. 12

Fig. 13 Drawing an arch in perspective

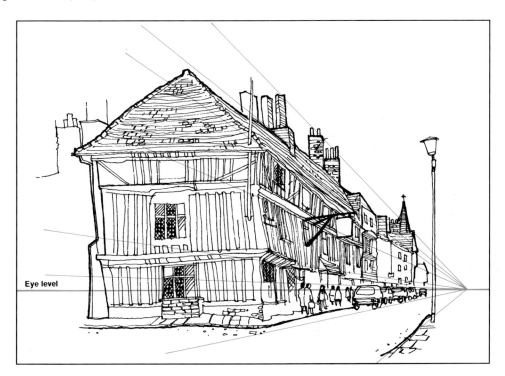

Fig. 14 Drawing showing perspective lines

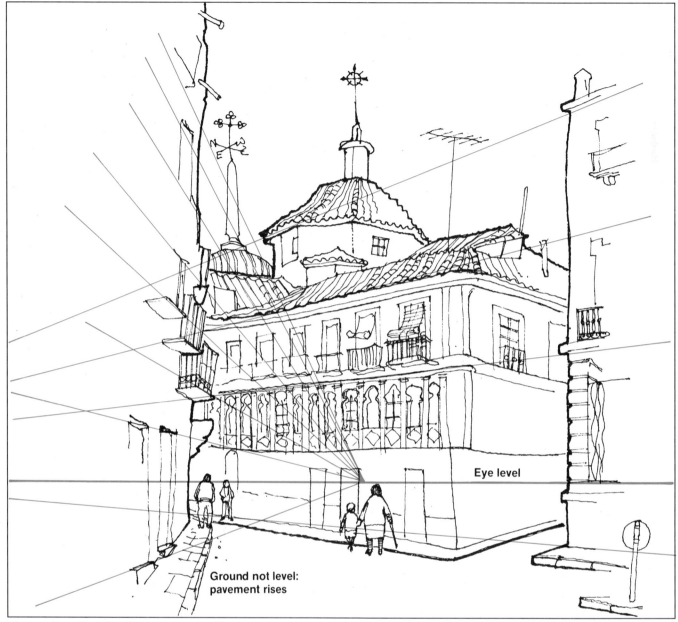

Fig. 15 Drawing showing perspective lines and (*opposite*) finished watercolour of Cuevas del Almanzora

Horsforth, Yorkshire

In **fig. 15**, of Cuevas del Almanzora in Spain, the houses on the left are not parallel to those across the square and consequently have a different vanishing point – opposite where I sat. The houses on the other side of the square have a vanishing point to my left. The pavement slopes upwards to the corner of the left-hand building, which is why its perspective line does not meet at the vanishing point in the centre.

The figures here are important for several reasons: they add life to the scene; they provide a sense of scale and proportion; and they give a feeling of depth and perspective to the picture. Notice particularly the difference in size between the two figures on the left. This emphasizes the distance they are from one another, separated by the road.

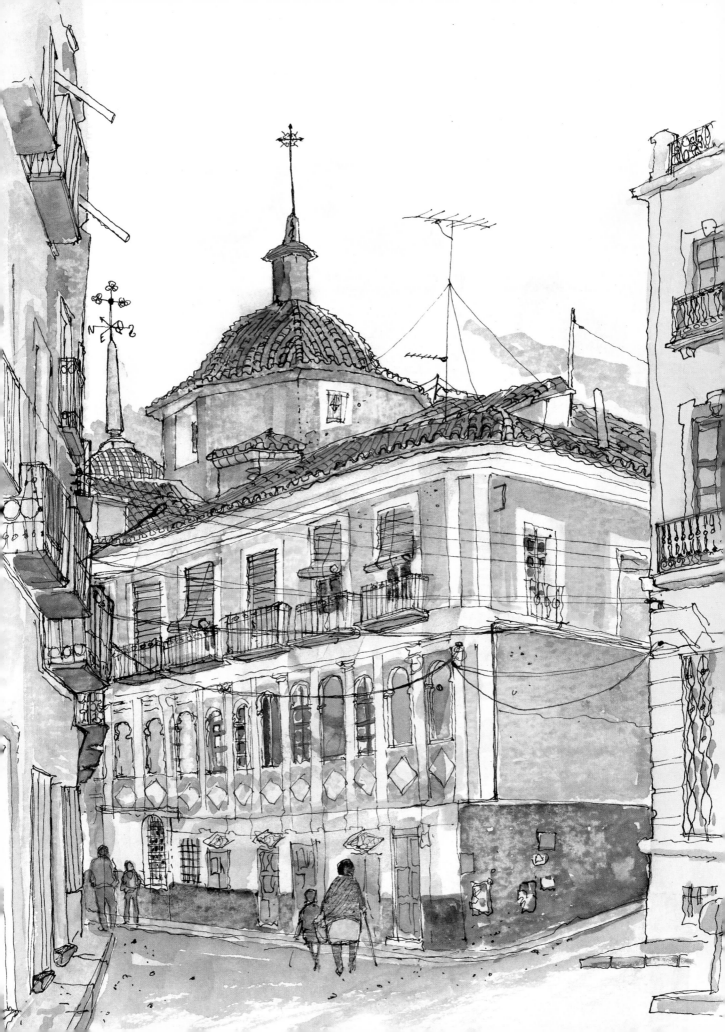

COMPOSITION

The word 'composition', in the context of art, is a rather confusing one; perhaps 'picture making' is a better phrase to use. A picture that works or is pleasing to the eye must show unification of the shapes within it and this particularly applies in the case of architectural subjects.

All buildings have a function and many of the buildings we see have been designed to be lived in or used as a place of work or pleasure. Their features have specific purposes: doors are to enter or leave by, windows to let light in and chimneys to take away smoke. The aim of the artist is to represent such three-

Fig. 17

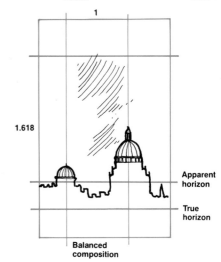

Fig. 18

Fig. 16

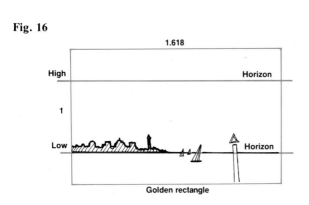

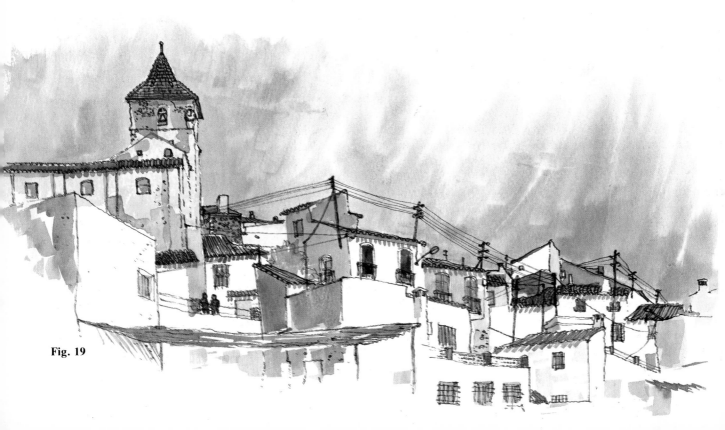

Fig. 19

Fig. 20

dimensional objects on a two-dimensional piece of paper. To obtain an appearance of reality is difficult enough in the first place without worrying about the composition. From the beginning, a two-dimensional drawing or painting is an abstraction of reality, and it is only by a number of symbols that we create a semblance of what we see or know is there. We can choose to represent this in a photographic, super-realistic, romantic, adventurous or perhaps abstract way, but whatever effect is required it is important to try to unify the shapes into a pattern that is pleasurable. If the arrangement of these shapes is just put together without thought and is not unified or balanced, there is little chance of success.

In addition to the shapes in a painting, there are other important factors that contribute to a well-designed and interesting composition and which you must consider: for example, the predominant colours used, the effects of light and shade, and, of course, the subject matter itself.

Figs. 16–18 illustrate some basic theories about good composition. Study them and think about them

carefully. As **fig. 16** shows, you should always place your horizon above or below the centre of your composition, never in the middle. Also, if you have a vertical feature on one side of a drawing, try to balance it by placing another one on the other side, otherwise the result will look lopsided. **Figs. 17** and **18** illustrate good examples of composition, following these rules; one has a high horizon, the other a low one.

In **fig. 19** it was the interesting skyline that attracted me. This sketch of Bedar in Spain was completed in $1\frac{1}{2}$ hours, using the small Daler-Rowney sketchbox and an architect's stylo pen on Bockingford 140 lb watercolour paper. It measures 343×178 mm ($13\frac{1}{2} \times 7$ in). **Fig. 20** illustrates a quick sketch of the Garrick Inn at Stratford-upon-Avon, and although it is a frontal view seen from across the street, there are nevertheless depth and some interesting shapes in it, especially in the roofs. I used a simple palette of French Ultramarine, Raw Umber, Raw Sienna and a little Ivory Black, painting quickly with a Diana Kolinsky No. 5 watercolour brush and finishing with a pen. It took me about 1 hour to complete.

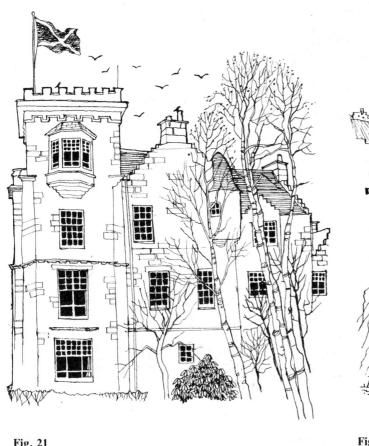

Fig. 21

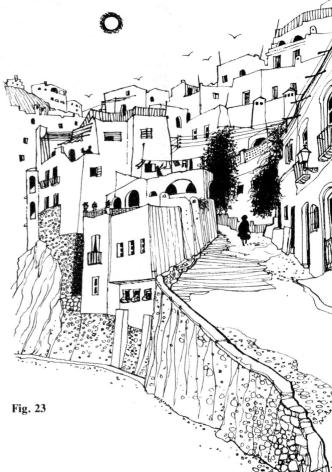

Fig. 23

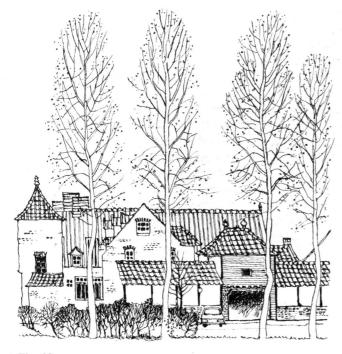

Fig. 22

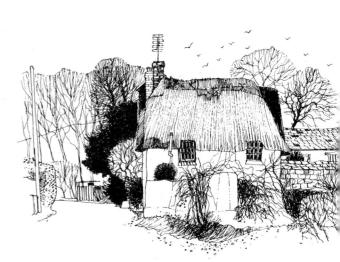

Fig. 24

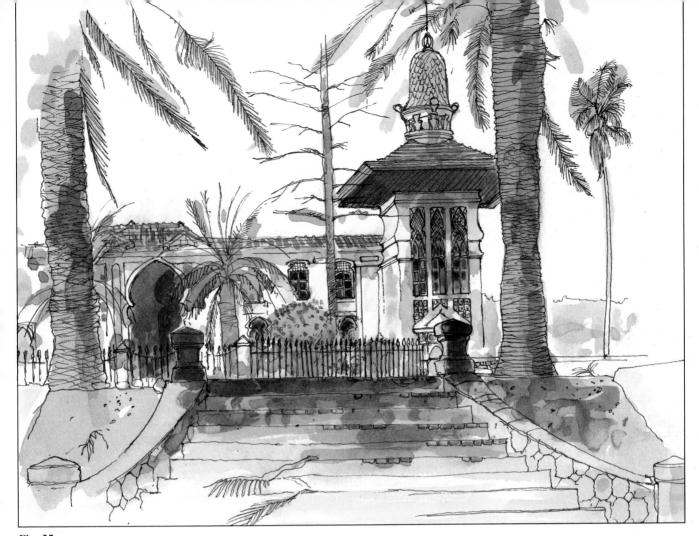

Fig. 25

In **figs. 21–24** different aspects of composition are considered. Two (**figs. 21** and **22**) are drawings of hotels taken from a hotel guide I illustrated and were drawn to a definite shape and size (133 × 120 mm/ 5¼ × 4¾ in), so I was concerned with making a balanced pattern on the page. They were drawn with a 0.25 stylo pen and, bearing in mind reproduction requirements, with lines which are firm and definite. In some ways restrictions such as these make the work easier because decoration rather than realism prevails. I will be discussing this aspect later in the chapter on house portraits. Trees, roofs, windows, etc., can all be treated simply and adapted to fit.

The street scene in Mojácar, Spain (**fig. 23**), is a simply treated line drawing using solid blocks to accentuate the patterns created by the windows. It measures 216 × 159 mm (8½ × 6¼ in). The composition, with the narrow street winding between the buildings, is such that the eye is led up and into the picture. The solitary black figure provides scale and a focus of interest. In contrast, the sketch in **fig. 24**, of Bowerchalke in Wiltshire, is quite different in composition and technique. Using a 0.25 stylo pen, I paid great attention to detail and pattern, putting in broken lines and quite heavy hatching, and placed the trees so that

they balance the little house. This was drawn from my car in January on thin cartridge paper and measures 178 × 102 mm (7 × 4 in).

The Spanish mansion near Garrucha in Almería which is illustrated in **fig. 25** was a fascinating building built by a wealthy man who later abandoned it; it is now in a state of total disrepair. A long avenue of palm trees leads from the main road some hundreds of yards to the steps in front of the house. I decided on this composition because the two great palms and the slope leading up to them have the effect of framing the house.

With a reversal of my normal technique I began the painting by making a pen drawing and later deciding to add colour. I used a small sketchbox and applied the basic colours of Burnt Sienna, Prussian Blue, Cadmium Yellow, Yellow Ochre, Light Red, Crimson Alizarin and a little Ivory Black with a Diana Kolinsky No. 5 watercolour brush. I darkened the top of the steps and the pillars with the shadow cast from the left-hand tree. The shadows under the roof and in the large doorway contrast with and emphasize the greywhite walls. The coloured Art Nouveau windows were also accentuated for the same reason, but I left the sky white. I wanted to convey the forlorn grandeur of the house and grounds.

25

The house and street in the ancient Podol district of Kiev in Russia (**fig. 26**) is one of my favourite compositions – and it just seemed to make itself. Measuring 229 × 229 mm (9 × 9 in), it is one of several watercolour sketches which I made on my Russian trip in a large hardback sketchbook containing watercolour paper. I sat on a low wall and drew and painted very quickly, using 0.25 and 0.70 stylo pens and a very limited palette of Prussian Blue, Raw Umber, Burnt Sienna and Raw Sienna. I worked alternately with pens and brush for 45 minutes on the spot and then finished the painting in a further 15 minutes back at my hotel. This composition breaks one rule, however: the road going out of the picture on the right tends to lead the eye away from the centre of the composition, although to a certain degree this is prevented by positioning the right-hand edge of the old cobbled street so that it directs the eye straight to the drainpipe of the house in the middle. In addition, the strong verticals of the lamp posts on the left and the bold drawing of the wooden house in the centre help to draw back the viewer's attention. The figures and the pigeons – dark against light and light against dark – add liveliness to the scene.

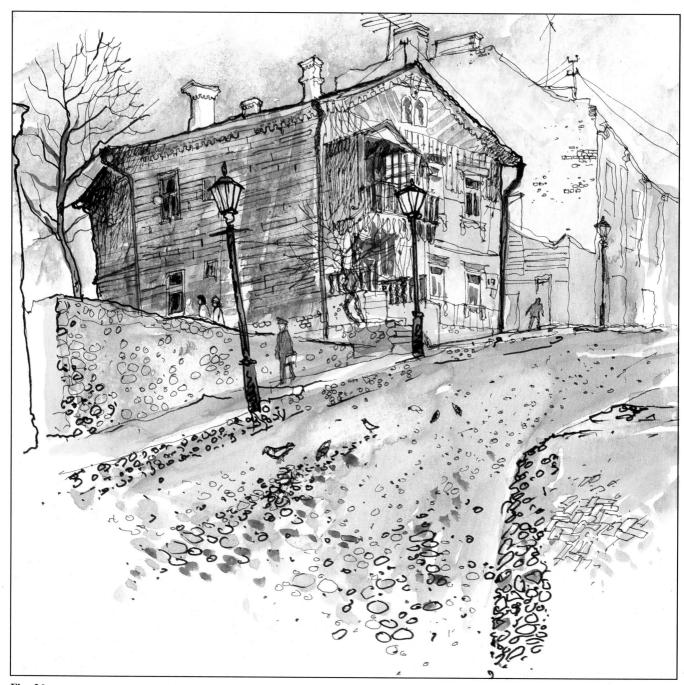

Fig. 26

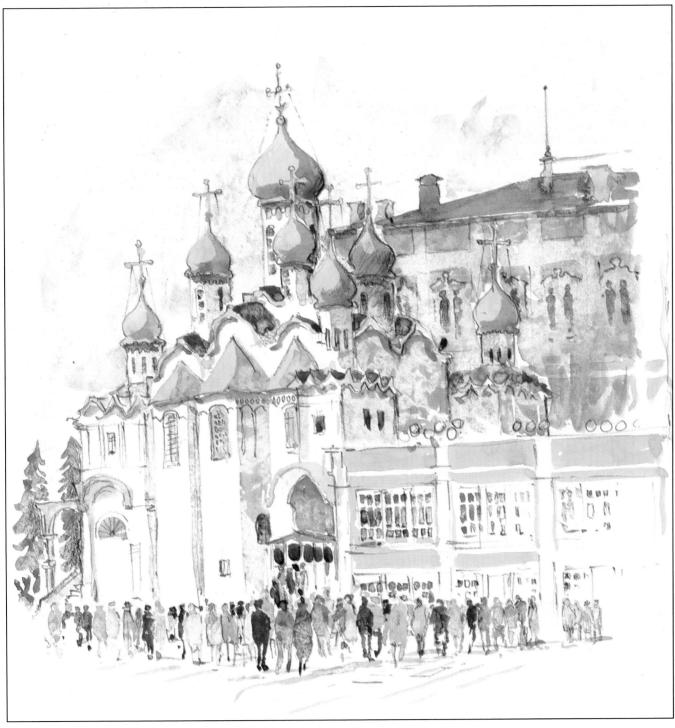

Fig. 27

The painting of the Cathedral of the Annunciation in the Kremlin (**fig. 27**) was a taxing exercise and took 1½ hours. It was painted entirely in watercolours, using the small Daler-Rowney combination watercolour box with twelve quarter pans and the tiny sable brush supplied with it. I put in the finishing touches lightly and in haste with a B pencil. The composition has strong vertical lines. I painted the domes first, however, because they were the most difficult shapes in the subject, and then worked down the building to the figures. The figures are essential to the composition and in such cases you should not be afraid to put them in. As they were constantly changing position I painted them group by group, from left to right. I used crumpled tissue paper to blot occasionally throughout this watercolour and this produced the textural effects which are especially evident on the blue-grey walls. The painting measures 178 × 190 mm (7 × 7½ in).

CHOOSING A SUBJECT

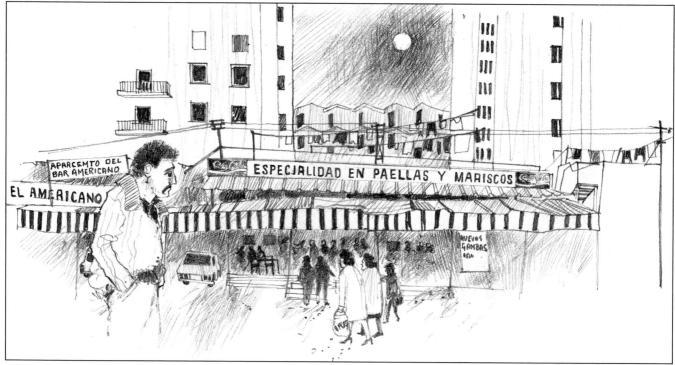

Fig. 28 and (*opposite*) **Fig. 29**

The choice of subject is probably the most important one you will have to make. Work only on a subject that really catches your interest. Success is more likely if you are excited, interested or moved by what you are drawing. There will be many occasions, however, when your choice is limited by time or situation; then you must try to make something of what is around you. Sometimes details or parts of the whole are as, if not more, interesting than the complete subject, so be observant and keep your eyes open. The more studies, drawings and watercolour sketches you make, the better you will be able to recognize a suitable subject and to assess how it will appear in two dimensions. With practice you will find that you begin to look through different eyes.

I have already advised you to keep a small pocket sketchbook with you always and I cannot emphasize too much how important this is. Even if you have time to make only the merest sketch and notes you will find this useful. Regular sketching and jotting down of ideas will help to keep your eyes alert and observant. A quick sketch with written notes and dates alongside will not be forgotten and you will find that ideas formulate with constant drawing in a sketchbook. It makes one humble to think that Turner, 150 years ago

when roads and transport were pretty bad, travelled through Yorkshire and in less than a month filled three sketchbooks with over four hundred drawings from which he afterwards made many finished watercolours.

The illustrations here are varied and were done in different media to suit each subject and my emotional reaction to it. The Spanish bar illustrated in **fig. 28** was a subject that amused me enormously. I sketched it and the figures with a B and a 2B pencil, adding tone by cross-hatching. When I work with a pencil I prefer to keep the lines and tones clean; I do not like smudged or rubbed pencil techniques. The lettering is very important in this sketch as are the figures in relation to the buildings. The ramshackle collection of huts against the dull, modern, concrete flats made me think that people often prefer to revert to disorder even though orderly blocks are built for them.

Fig. 29, of St Bartholomew's in London, was a sketch for a commissioned painting and demonstrates an exception which breaks one of the rules of composition: it features a straight-on view leading into the centre of the subject. A very limited palette was used: Ivory Black, Light Red, Burnt Sienna, French Ultramarine, Raw Sienna and a touch of Crimson Alizarin.

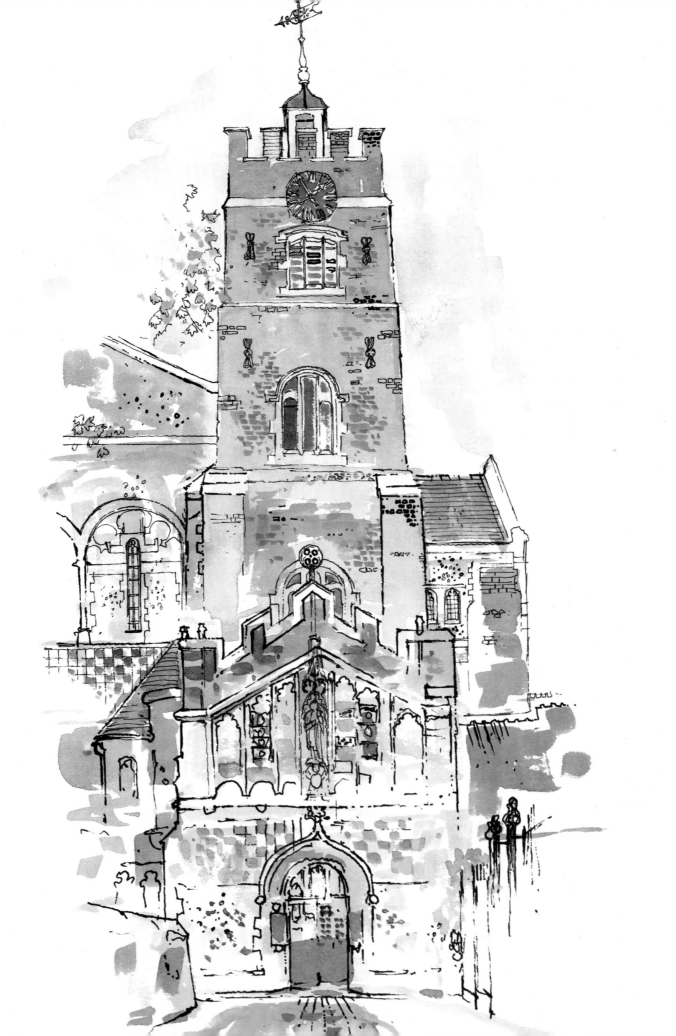

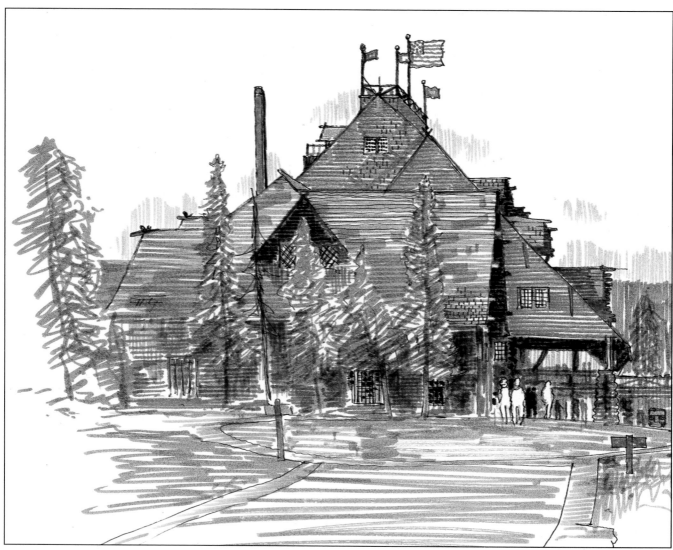

Fig. 30

The drawing of the Old Faithful Inn in Yellowstone Park, Wyoming (**fig. 30**), was carried out with water-colour-based fibre-tipped pens. These come in basic colours and so are most suitable for bold subjects. They depict the linear quality of this subject very well.

The quick sketch of the Trinity Gateway church in the Kiev Pechery Lavra (**fig. 31**) was made in 1 hour whilst I was sitting on a wall. I used a small water-colour sketchbox and a 0.25 stylo pen, and limited the colours to Yellow Ochre and a hint of Cadmium Red for the gold domes, and Prussian Blue, French Ultra-marine, Ivory Black, Cadmium Yellow and Crimson Alizarin for the rest of the sketch. I began with the colour bright and strong and finished with line.

This was a lovely subject to paint; it was so peaceful in this former monastery, now a museum. Notice how the lines of the paving feed into the picture, leading to the great dome and gateway in the centre. The receding trees, railings, birds and figures all accentuate the dramatic perspective of the composition. This is a

Fig. 31

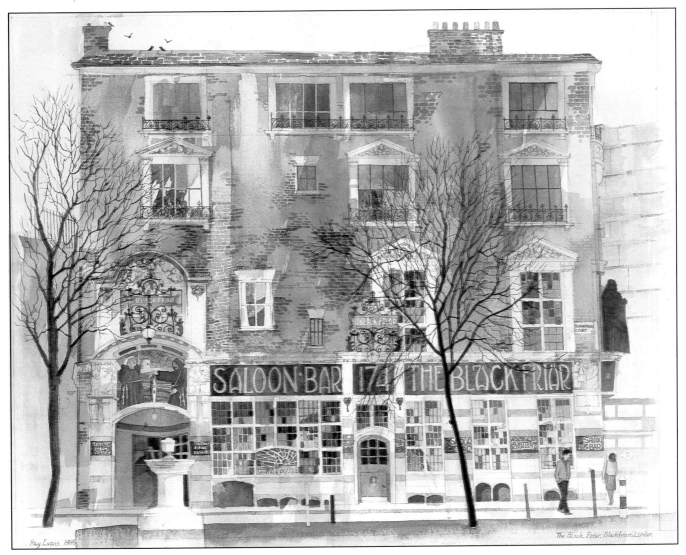

Fig. 32

great contrast to the drawing of the Spanish bar and also to other subjects in this section.

The Black Friar (**fig. 32**) is a studio painting for the Spring Exhibition of the Royal Institute of Painters in Watercolour. It is one of a series of paintings of pubs which I have carried out over the years, some as commissions for breweries, others because I find pubs very paintable. London has a feast of Victorian and Edwardian public houses built on the grand scale. This particular one was painted on 140 lb Rough watercolour paper, stretched on a board, and it measures about 711 × 610 mm (28 × 24 in) in its frame. Before I started painting, however, I made two watercolour sketches on the spot and took a complete film of colour prints showing various parts of the building. Some of these included close-ups of the mosaic lettering and designs on the walls.

I began the painting here by making a careful pencil drawing and then I cut a mask using masking film with a matt surface. This is a transparent film, so when placed over a drawing, details can easily be seen. It is available at your art dealer's shop. The technique for using it is described in the section on using mixed media (see page 16). I used a sharp, pointed knife to cut the stencil, being careful not to cut through the backing paper of the film. Once I had cut out windows and doors where I thought necessary, I removed the backing paper and placed the stencil back over the drawing. Then I washed colour over the stencil onto the drawing beneath. This technique results in the effect of a lithograph. Finally I removed the film and gently washed out over the drawing with a large brush.

This technique may seem rather tedious but it creates a very interesting pattern of shapes on which to base a painting. Further colours can be added with more stencils. It took me two days to complete this watercolour. For me, this sort of painting is a challenge and although the process of using stencils and washing out sounds rather mechanical, the end product is a decorative and interesting painting.

DRAWING

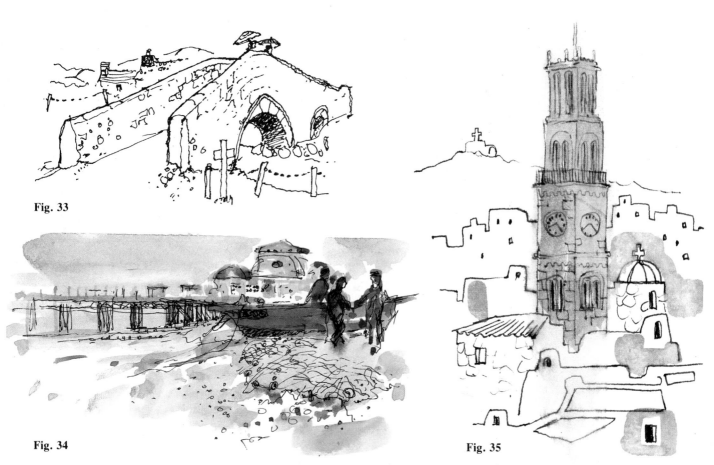

Fig. 33

Fig. 34

Fig. 35

Do not be misled into thinking that drawing means simply working in line with a pen or pencil. You are drawing when you are working in watercolour with a brush, too. In drawing, like anything else, practice tends to make perfect. If you do not constantly practise your drawing, little improvement will be achieved, so never miss an opportunity to do so. As you draw, bear these points in mind: a double line is more telling than a single line, and a slightly wobbly or broken line is more interesting than a straight one: solid black shapes for windows should always have clean edges and not be too big.

The basis of every finished painting must lie in drawing, but in this chapter I have chosen to illustrate a selection of work where the emphasis is on drawing only, using simple line, line and wash, and line and watercolour.

All these sketches are very quick drawings and they illustrate the important points made in the previous chapters on perspective, composition and choosing a subject. None took more than half an hour and **fig. 33**, of the packhorse bridge at Linton in Yorkshire, took

hardly 10 minutes, with a fountain pen. The pier at Worthing in Sussex (**fig. 34**) was completed in 10 or 12 minutes, as were the small watercolour and pen sketches of Greek houses (**figs. 35** and **37**), but although finished quickly the drawing in them is still sharp and decisive. The wash drawing of Wilton House (**fig. 36**) was carried out whilst I was sitting on a seat in the grounds before attending an outside theatre performance. It is on just such an occasion, when you have half an hour to spare, that you will be glad if you have followed my advice and have a small sketchbook and watercolour box in your pocket. This has become an automatic habit with me. For this sketch I used a 0.25 stylo pen, again showing attention to detail, and then added a sepia wash which, in limited time, gives a drawing more finish. The drawing of the clock tower in Salisbury (**fig. 38**) took 20 minutes with a stylo pen whilst I sat in a café drinking coffee. Again, despite being a quick sketch, it shows careful attention to detail and perspective. **Fig. 39**, of a parador in Malaga, is included here because it is a good example of an illustration with very precise line and detail.

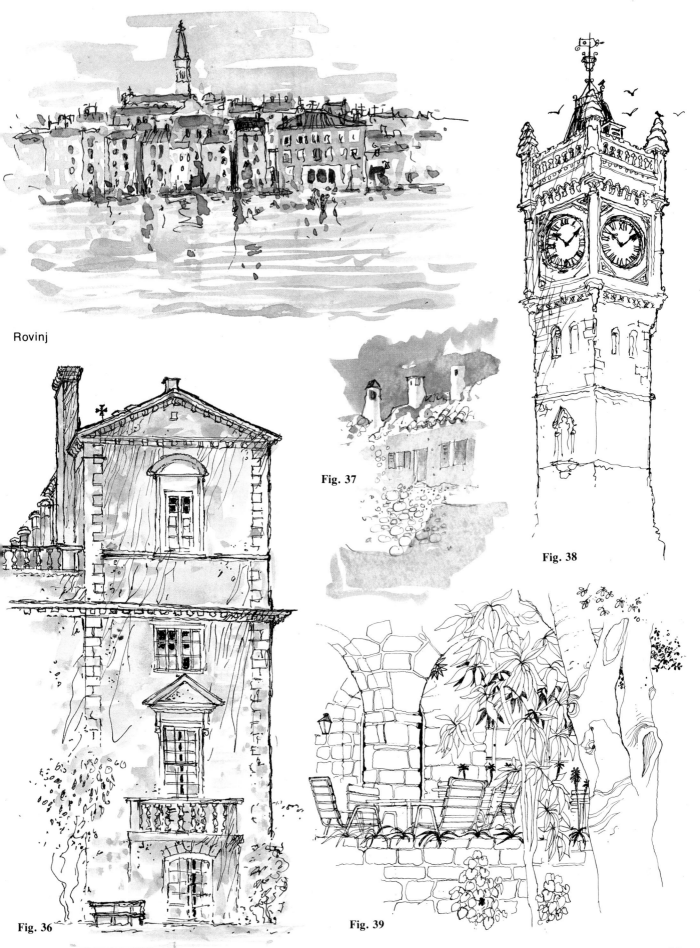

Rovinj

Fig. 36

Fig. 37

Fig. 38

Fig. 39

33

Fig. 40 and (*below*) Fig. 41

Fig. 42

Figs. 40–42, of the village of Bowerchalke in Wiltshire, make interesting comparisons as they were drawn from the same position. It was a useful exercise to make these drawings with different media and to note the similarities and differences that each medium dictated. Each drawing measures approximately 152 × 279 mm (6 × 11 in) and was drawn on a pad of thin cartridge paper. **Fig. 40** took 2 hours of careful work using a B and a 2B pencil. I started at the top of the drawing with the village and trees, working from left to right, and then moved down to the foreground. Although there is some solid tone on the roofs I have kept the pencil strokes very open. I made this sketch at about the end of December or the beginning of January, and at this time of year the trees are particularly interesting in relation to each other. They make perfect patterns seen from a distance and form good shapes one behind another.

When I began the pen drawing (**fig. 41**) I knew the subject better so it took only 1½ hours. The pen is the harshest medium but the 0.18 stylo pen used for this drawing portrays the fine tracery of the trees very well. Vertical lines hatched down the trees pull the shapes together, but I left more white paper for the hills behind the trees than I did in the pencil drawing because more lines would have caused confusion. As I was using a pen, detail is more important and the drawing of the foreground is more precise.

Fig. 42 is similar to **fig. 40** and also took 2 hours. For this I used Berol pencils – Crimson Lake, Warm Dark Grey, Sepia, Olive Green, Light Blue, Warm Grey Medium, Slate Grey and Yellow Ochre – and drew carefully with very sharp points. A knife was essential to keep them that way. I also used an eraser but only to clean the paper after I had finished drawing. I believe the use of an eraser to remove 'mistakes' encourages a negative approach. I used each colour separately, stroking it on without rubbing it. You can create tone and colour where you need it, as for the left-hand houses and roofs here, by hatching or drawing parallel lines close together. I have tended to make vertical strokes with the coloured pencils to suggest the hills behind, the field in the foreground and the trees in the background.

I chose to use pencils, coloured pencils and a pen to make these drawings but I could just as easily have used watercolours, gouache or acrylics. Similarly I could have worked on different surfaces, perhaps making fairly quick sketches rather than these rather careful drawings. The point I am making is that you should try various methods if you wish to improve your drawing and not fall into the trap of using one particular technique continually. If you do this your work will eventually become sterile.

KEEPING A SKETCHBOOK

Since the revolution of the 1960s when figurative subjects were frowned upon there has been a decline in the use of the sketchbook. I am glad to note, however, that the pendulum has now swung back in its favour. When I was teaching I used to insist on the use of sketchbooks; some of my students who have since done well in their art careers produced very good ones. At one time, in fact, a sketchbook was an automatic extension of an artist's arm; this is evident in the sketchbooks of Turner and Constable which are reproduced for study today. It is a truism that the best work of many artists can be found in their sketchbooks and this is probably because most sketchbook work is uninhibited. It is done without the worry of what people will think of it, or whether the client will like it, or the public buy it, or even the gallery approve of it. In general, sketchbook work should be for private viewing or as a reference for studio work. Nowadays, however, we are fortunate to be able to see the best sketches and fieldwork of well-known contemporary artists such as Ken Howard, David Gentleman, Hugh Casson, Paul Hogarth, Rowland Hilder, John Blockley, Moira Huntly and David Hockney in their books.

I believe, therefore, that the sketchbook is the most valuable of all your pieces of equipment. On my travels I am never without two sorts of sketchbook: one for the pocket and a larger one for longer studies. I often start a new sketchbook for each journey – perhaps one for America, one for Russia and another for Yorkshire as Turner did. Try to develop a love of sketching, even if you feel it is a bit of a chore and would rather just walk and look at buildings. Get into the habit of making quick notes and studies of architectural features on the spot. These might be the merest sketches or quite finished small studies perhaps using colour. Date each page of these small sketchbooks and they will be of immense value and great interest when you look back through them over the years. Remember that the subject you draw will be engraved on your mind as well as on paper, because the mere act of drawing is also an act of learning about the subject. The more you draw, the keener your eye will become at noticing details; the more adept you become at the techniques of drawing, the better you will record what you see. In fact, the more you draw, the more you will want to draw. I find that my hand often itches to get out a pad and start sketching!

Another advantage of keeping a sketchbook is that the more sketches you amass, the more material you will have at hand to work from when winter draws in or when the weather is bad. Turner accumulated thousands of pencil drawings, many of which he turned into quite elaborate watercolour paintings or even large oils several years after making them. When I am working on larger studio work I like to experiment – making it decorative and adventurous and not simply producing more careful copies of work already carried out in sketchbooks.

Some of the drawings in this chapter are shown as near actual size as possible, because there is some loss of detail in reduced reproduction. All are from sketchbooks and in most cases I have indicated the approximate time each one took.

The sketches shown in **fig. 43** are typical of the kind you might make in your sketchbook. As I strolled on the beach at St Malo in France and watched the sun go down I was inspired to make several sketches and in the one opposite I was looking across to the Fort National. The sketch, which measures 51×165 mm ($2 \times 6\frac{1}{2}$ in), took about 10 minutes and was drawn with line and a limited palette. The Ross Hall fountain pen sketch is one of five or six compositional sketches, each made in 2 or 3 minutes, from which one was subsequently chosen as the basis for a watercolour. This and the sketch of Lynmouth, which took about 10 minutes to draw, were both carried out in a pocket sketchbook measuring 140×102 mm ($5\frac{1}{2} \times 4$ in). The interior of Salisbury Cathedral was also drawn in a pocket sketchbook in 40 minutes whilst I was waiting for the carol service to begin. The skyline sketch of Veurne, with its baroque buildings, was drawn in a little park as dusk fell.

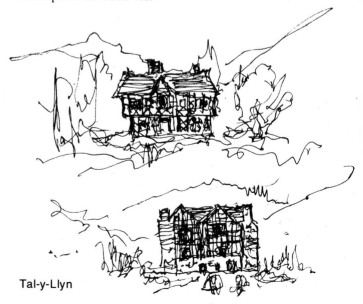

Tal-y-Llyn

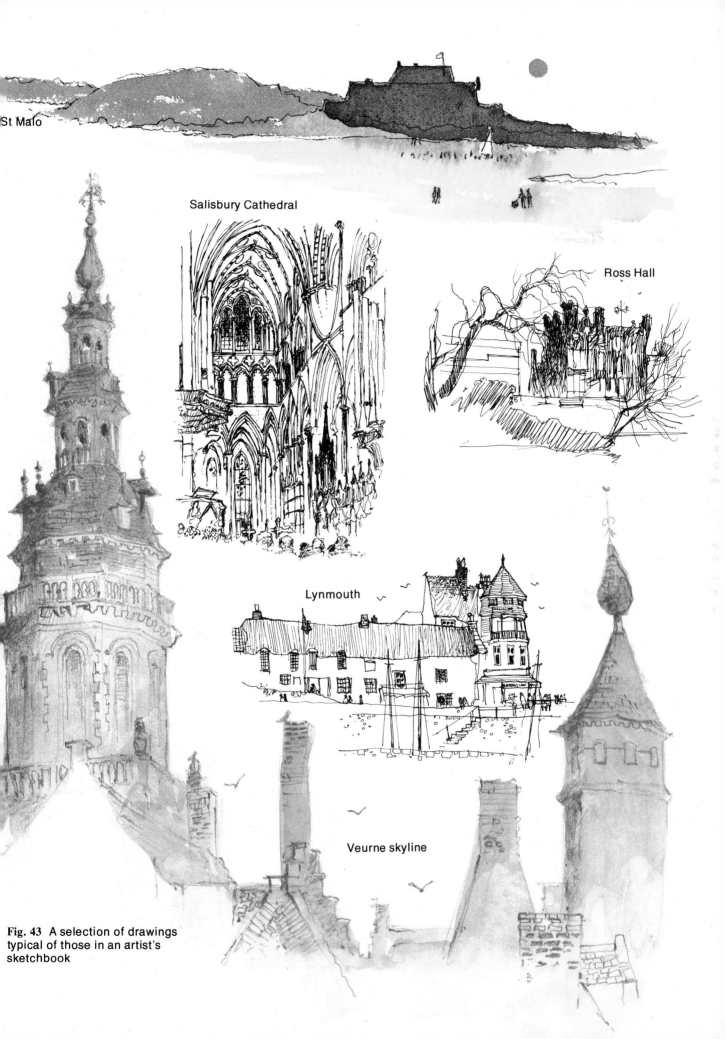

St Malo

Salisbury Cathedral

Ross Hall

Lynmouth

Veurne skyline

Fig. 43 A selection of drawings typical of those in an artist's sketchbook

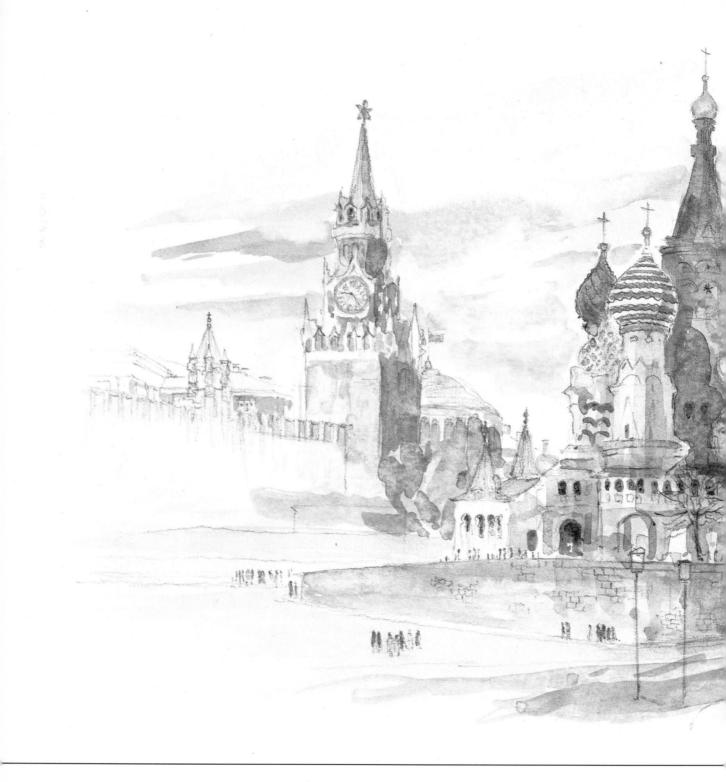

Fig. 44

The watercolour of St Basil's Cathedral, Moscow (**fig. 44**), was painted in a much larger sketchbook measuring 317×254 mm ($12\frac{1}{2} \times 10$ in). I turned the book round to take advantage of the additional width, for the painting measures 203×279 mm (8×11 in). It took me $2\frac{1}{2}$ hours and was drawn with a B pencil, watercolours and crayons. Since the architecture was so complicated I did not have the courage to tackle the

drawing straight away with watercolour washes. I drew lightly with a B pencil and some crayon first, while my eyes were learning to absorb the extraordinary shapes, before washing in colours. As a general rule, however, be bold in your sketching – confidence comes from constant practice – and try to draw sometimes directly with watercolour; you will be surprised how effective the result can be without the 'security' of line work. If you look at **fig. 45** you will see a half-hour watercolour sketch of the same subject

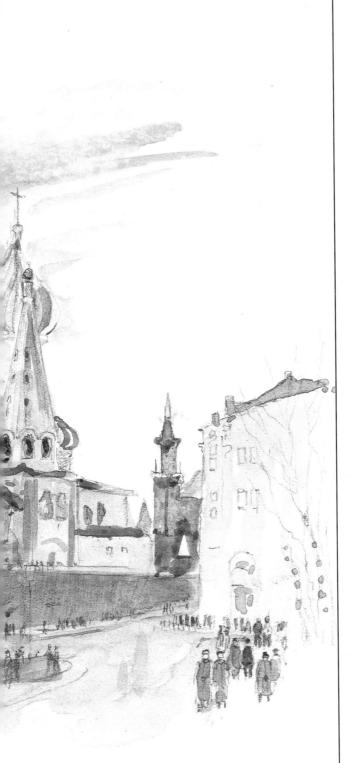

Fig. 45

Fig. 46

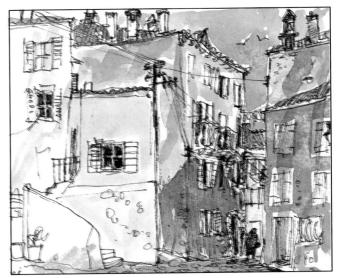

painted directly in colour without line. I did this sketch, which measures 127 × 165 mm (5 × 6½ in), two days after the first when I had had time to get used to the incredible architecture of the buildings of the Kremlin. Both sketches were drawn from my hotel.

The two sketches of Vezeley in France (**fig. 46**) and Rovinj in Yugoslavia (**fig. 47**) show how fairly complicated subjects can be depicted within the confines of a small 102 × 152 mm (4 × 6 in) sketchbook. In both cases I used an architect's pen and watercolours.

Fig. 47

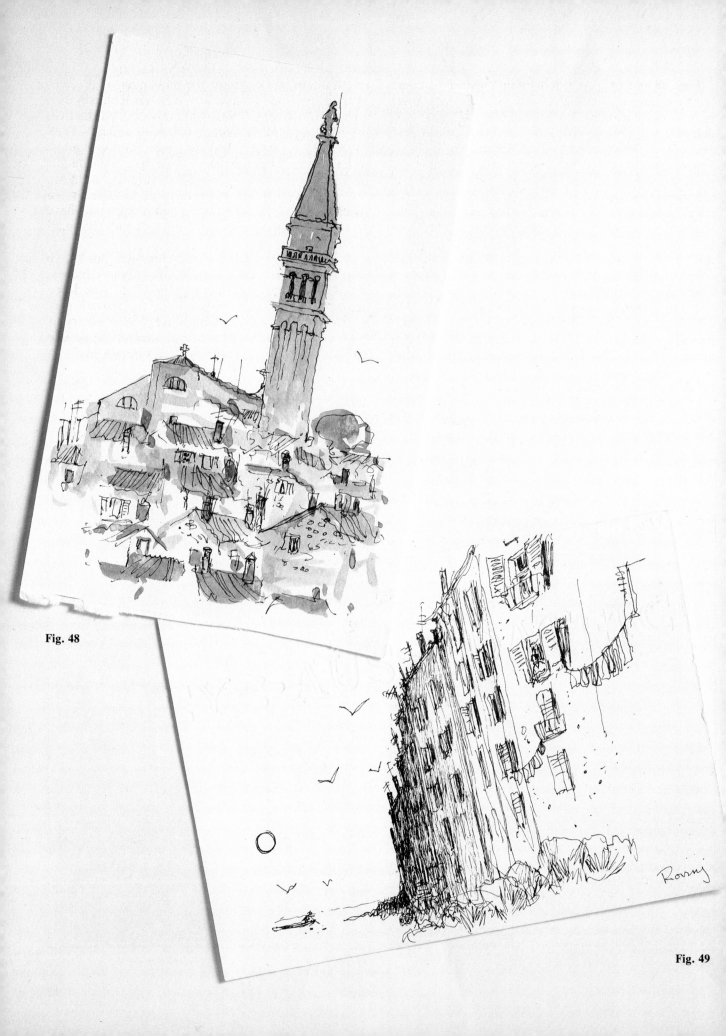

Fig. 48

Fig. 49

Figs. 48 and **49**, also of Rovinj in Yugoslavia, come from the same pocket sketchbook and are quick notes of this lovely small medieval town. Mediterranean and Adriatic architecture has fascinated me since I first saw it as a young soldier in the Second World War. The tall campaniles, the low-pitched, overhanging, Roman tiled roofs, and the high, stone, white- or colour-washed walls are very paintable. So too are the tall casement windows, the rickety balconies hung with starched white and brightly coloured laundry, and the brilliant flowers in coloured biscuit tins – all nectar to the hungry artist! These two pictures are both very simple statements, drawn with obvious great enjoyment in watercolour and line.

I used a small Langton watercolour book, 127 × 178 mm (5 × 7 in), containing Bockingford 140 lb paper for the sketch of the fountain at Vera in Almería, Spain (**fig. 50**). I enjoyed this fairly complicated subject and treated it as simply as possible. I spent 40 minutes on it and although at the time I felt I had not the time to do the subject justice, on reflection I doubt if I could have improved on this impression if I had had a larger pad and 2 hours to spare. The statues on

the fountain, dark against the remainder of the subject, were painted in first, with a Diana Kolinsky No. 3 watercolour brush. Next I broadly painted the tree, the buildings and the foreground with a Dalon D.88 13 mm ($\frac{1}{2}$ in) brush, leaving space for the figures, which I added later. I finished by putting in the details of the fountain railings, verandah railings, windows and lamp with a 0.25 technical pen; to have drawn details on this scale with watercolour alone would have been difficult. This detailing helped to pull the small sketch together.

There was a festival on the day I painted this sketch and there were many people, including children, about. They were very interested in what I was doing and watched me as I worked, but fortunately they were very polite and not a nuisance. You must try to get used to sketching with people around: be at ease and smile at them and try not to be surly, even if you feel that way!

I do not think that I am ever happier than when I am prowling around a strange or foreign town making sketches. This is the best way to learn, so promise yourself never to be without a sketchbook in your pocket.

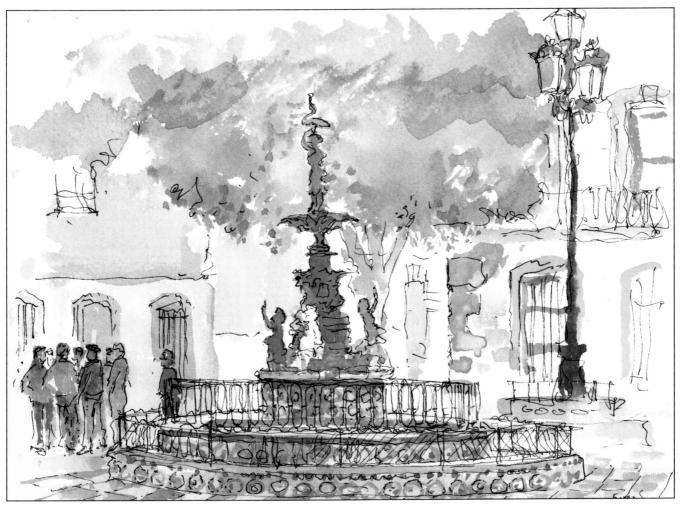

Fig. 50

41

COUNTRY BUILDINGS

There is less hassle when drawing in the country than in the city. It is generally easier to find a place to draw from and buildings, farms and cottages can be inspected from all angles to find the most attractive view. Owners or interested tenants can more easily be found to ask about details of the history or background of the subject and its environs – I prefer to know something of what I am drawing. The village publican, the pub customers, the vicar and the village postmaster are usually mines of information. There seems to be a lot more trust and friendship away from the large centres of population. Sketching and painting country buildings is also less demanding in technique and offers a more relaxed way of drawing. Country buildings tend to be more isolated, older, even dilapidated perhaps, and with signs of alterations made over the years.

In this chapter I have chosen to include drawings in a variety of media. Each drawing has its own piece of history attached, much of which can be read in the building itself and also because I keep written notes alongside most sketches. I know, for example, that the goat in the shack (**fig. 51**) was sketched in 20 minutes as I ate a picnic lunch with a sketching party I organized in Devon. In the end we all drew the scattering of huts and chicken coops behind the farm, though it was the farm itself we had come to look at and work on. It was an untidy scene but very exciting visually. This small gouache sketch was carried out in a sketchbook made up with David Cox-type watercolour paper – a yellowish paper with a rather rough surface. I used watercolours with Chinese White and a No. 303 Gillott nib for the ink work. The painting measures 114 × 165 mm (4½ × 6½ in).

The pencil drawing in **fig. 52** of the clapboard house in the small town of Essex, Connecticut, measures 127 × 216 mm (5 × 8½ in) and was drawn with a B and a 2B pencil on thin cartridge paper. The patterns made by the many varied trees and bushes, evergreen and deciduous, with their fine tracery or solid dark tones,

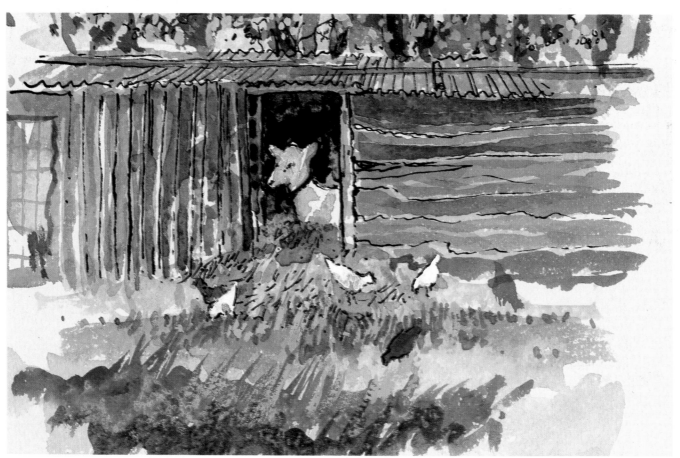

Fig. 51

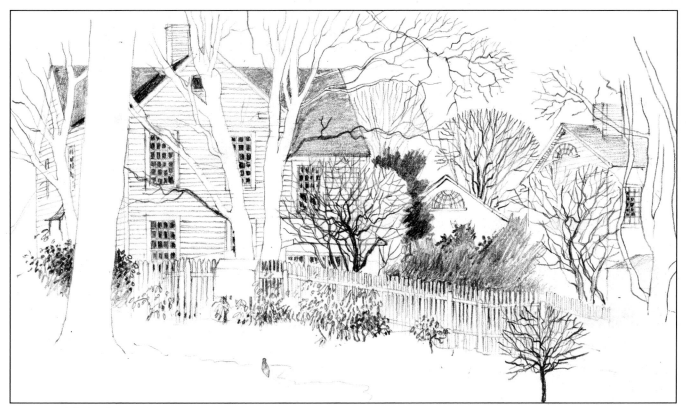

Fig. 52 and (*below*) Fig. 53

are an excellent foil to the houses. The tree trunks were not actually white, of course, but I left them that way in the drawing because they made an attractive pattern against the clapboard. The white fence helped in the same way. Note how I have drawn the dark roof round the branches.

Fig. 53, 82 × 203 mm (3¼ × 8 in), illustrates the farm at Itchenstoke in Hampshire and was painted on the same David Cox-type paper as **fig. 51**. Toned paper makes a pleasant and interesting change from white paper; the Daler-Rowney Ingres sketchbooks, for instance, are excellent. It can also make things easier because the tone of the paper can be used as part of

your drawing, worked to dark or conversely to white, thereby achieving a sparkling contrast. Here I used a muted palette of Olive Green, Brown Madder Alizarin, Raw Umber and a little Ivory Black, with gouache white on the houses and sky. The line was drawn with a No. 170 Gillott nib and sepia ink. This was a quick note of the subject, taking half an hour.

For this painting I positioned myself to ensure that the farmhouse was framed by trees. When drawing buildings in the middle distance, as here, use the ploy, as I have, of putting a fence or some trees in the foreground. This helps to add depth to your picture. If you are unsure about drawing animals,

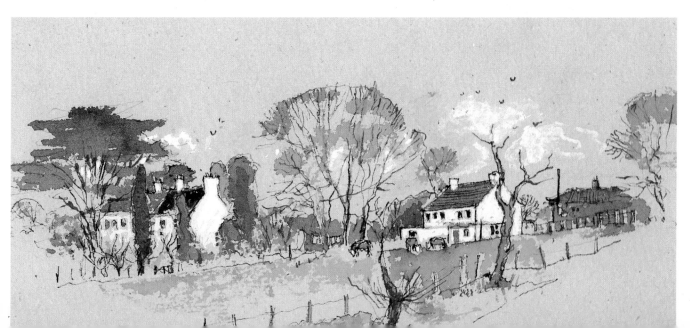

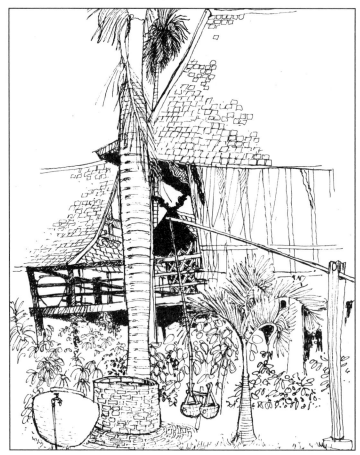

Fig. 54

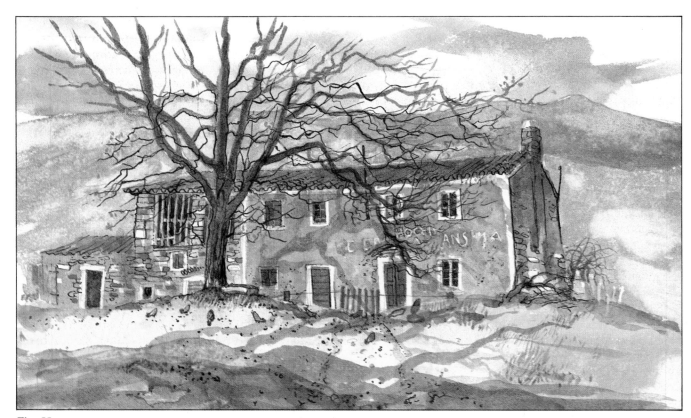

Fig. 55

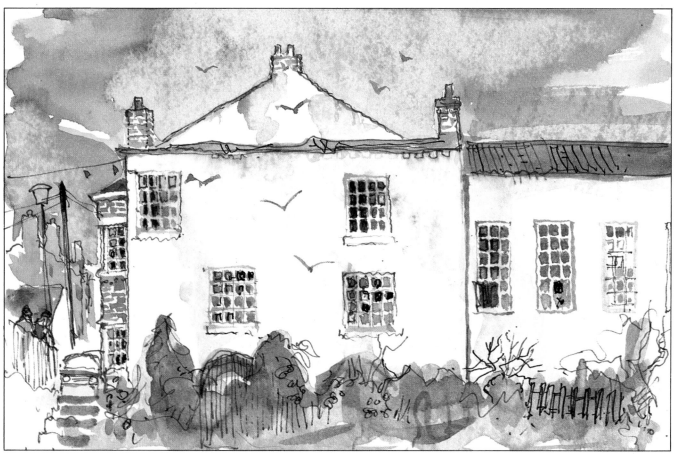

Fig. 56

practise making some pencil or line drawings of them in a small sketchbook first and then transfer the best results to your painting later. It is preferable to suggest them in colour and add some line afterwards.

Fig. 54 illustrates a Kamtheing village house in Bangkok, Thailand. It was drawn with a technical pen in about 1 hour and measures 203 × 152 mm (8 × 6 in). It shows careful use of solid blacks against more delicate fine line. The tall palm tree in the centre suggested the vertical nature of this composition.

The watercolour of the farmhouse in Istria in Yugoslavia (**fig. 55**), measuring 152 × 254 mm (6 × 10 in), was painted in the studio from a line drawing in conjunction with several photographs. I painted it on Fashion board, which has a fine-grained Not surface and enough bite in it to create a very nice texture on the hills, farmhouse and foreground. I began with pencil, adding colour later. The lettering and the white areas around the doors and wall edges were achieved by masking out. I use an architect's ruling pen to apply masking fluid because brushes are ruined by it. The fluid runs finely off the point for fine lines and flows out more quickly from the side if the pen is angled. Masking fluid can be used at any stage in a painting, not necessarily at the beginning. It can also be used over another colour.

The colour was applied very strongly and washed out repeatedly. I used a palette of Prussian Blue, Brown Madder Alizarin, Burnt Sienna, Cadmium Yellow, Raw Umber and Rose Madder Alizarin. The textures were achieved with a large, square-ended brush and when each wash was nearly dry it was washed out and blotted. The end wall of the house and the foreground were painted with sepia ink, some of which was then washed away by putting the board under the tap. This must be done almost immediately as the ink dries very quickly. Again this procedure left an interesting texture. When the colour was dry the masking fluid was rubbed away to reveal the white board. I finished the painting with line, using black Indian ink and a No. 303 Gillott nib.

The sketch of the old convent in the county town of Newtown, Powys (**fig. 56**), is an example of a quick, 20-minute composition in a pocket sketchbook. I subsequently worked up this subject in watercolour on my easel in a demonstration to some students. I was particularly attracted by the very dark sky, a black thunder cloud which made the white building with its patterned windows stand out in a startling way. I used Burnt Sienna, Prussian Blue, Warm Sepia, Brown Madder Alizarin, and a 0.25 technical pen to put in the detail.

EXERCISE ONE

This studio painting of a house in Edenton, North Carolina, USA, was based on a small stylo pen drawing (see below) and a photograph. It took 2 hours to complete.

First stage I started by making a careful HB pencil drawing on Bockingford 140 lb paper in a Langton sketchpad (254 × 178 mm/10 × 7 in), which meant I did not need to stretch the paper. I put in enough detail – especially in the windows, porch and position of the trees – to give a good basis for the watercolour painting.

Then, using a Dalon D.88 19 mm (¾ in) wash brush I washed over the whole area with plain water, beginning with the sky and going carefully around the house and over the trees. I allowed this wash to dry a little and then dropped some colour into it – Monestial Blue, a touch of Ivory Black and a very little Crimson Alizarin – with a Dalon D.77 No. 5 brush. I let the colour run into the damp paper – the wet-into-wet process – but left some white parts to give the appearance of an April day of sun and cloud. When this colour was half dry I washed out areas with the large wash brush, dragging it gently over the surface, and then blotted with a clean sheet of white blotting paper to create texture. The same process was repeated with the foreground grass and bushes, using Monestial Blue, Cadmium Yellow and a hint of Ivory Black. Remember that it is best not to wash out too soon and to use strong colours, otherwise they will vanish completely. There is an element of chance in watercolour painting which can be exploited by using techniques such as washing out to give interesting textural effects.

To complete this stage I washed in the shingle roof with Burnt Sienna and a touch of Yellow Ochre, and painted in the shape of the trees with a light wash of grey mixed from Ivory Black and a hint of Yellow Ochre. Then almost immediately the roof and trees were blotted. Finally I suggested the shape of the shutters and the shadow in the doorway with a light wash of Monestial Blue with a touch of Ivory Black.

Second stage In this stage the composition came together as I painted in the tree branches with a mixture of Burnt Sienna and Burnt Umber. Next I darkened the shutters, still blotting occasionally. Some careful work followed in the windows and doorway, using a fine Dalon D.77 No. 1 brush, darkening with blue-black or red where appropriate – and still blotting every now and again. A darker wash of blue-green was added to the foreground bushes and grass, and the brick path was painted in with Burnt Sienna and a little Cadmium Red, blotted again.

Finished stage Now, after all the groundwork, the exciting and interesting part began. I used Burnt Umber over the roof to make it darker and then blotted it. Next I darkened the foreground bushes, the shutters and some of the windows.

I finished the painting by adding the pen work, using a No. 170 Gillott nib and Indian ink. I drew in the detail of the clapboards, porch, trees and bricks, so bringing all elements of the picture together. This method of simply picking out detail in ink keeps a feeling of freedom in the work. If you draw in ink first and then add colour you will merely produce a coloured drawing.

The final touch was to add some strong Monestial Blue shadows under the eaves, porch and bushes, and the shadow of the tree over the front of the house. This strong colour was gently blotted. A few window panes were lightened with gouache white and a scattering of birds were added. There must be plenty of contrast in this painting and if this is lacking in your version, try darkening the windows, shutters and other details.

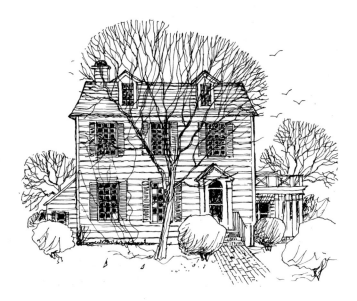

Stylo pen drawing

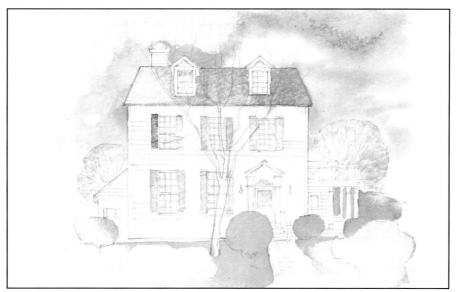

Fig. 57 First stage

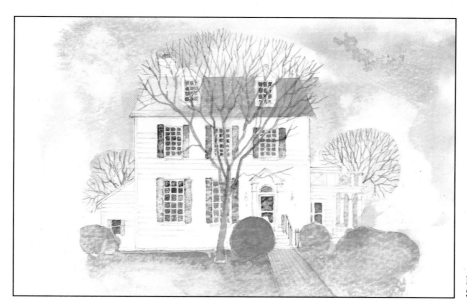

Fig. 58
Second stage

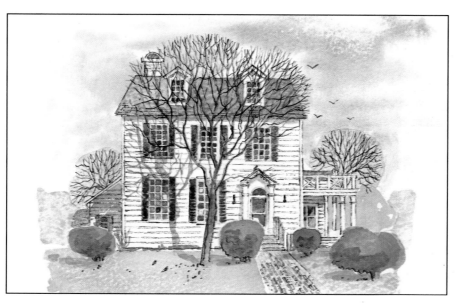

Fig. 59
Finished stage

TOWNSCAPES

The skyline sketch of the baroque roof and tower in Veurne, Belgium (**fig. 60**), was drawn with a 0.25 technical pen across two pages of a pocket sketchbook measuring 102 × 152 mm (4 × 6 in). I used cross-hatching to accentuate the tower roof, dark against the sky, and to pick out the decorative shape of the gable ends. Notice how I have drawn the tiles on the roof: some are just outlined, while others are filled in with black. I drew only the outline of the chimney on the left, without filling in any detail, because I felt I had finished the drawing at this stage.

The drawing of the Old State House in Boston (**fig. 61**) was drawn with a fountain pen. The shape of the dome was the most testing part of the drawing. With a difficult subject like this it will take you some time and much careful drawing before you will be sure the proportions are correct. I began tentatively with a faint line from the top of the cupola down through the centre of the dome; I knew that by making the extremities of the tower and the dome equidistant from this line and by balancing the curves on each side, my drawing would be correct. Any faint construction lines which you may put in to help you with your drawing will disappear into it as it progresses. Once the dome had been accurately positioned, the rest of the building was completed from the centre downwards and outwards to the railings and trees. The finished drawing measures 178 × 165 mm (7 × 6½ in).

This drawing took 1½ hours to complete. If I had made a very quick drawing, perhaps in line and watercolour, in 20 minutes maybe, I would probably still have finished with a drawing which was fairly correct in proportion and shape. There is a danger that if you begin to take longer, the drawing can take over – lines can become nervous and tentative, and you may become fearful of making mistakes. I was not actually pleased with this drawing – I have overworked the detail, particularly in the brickwork – but I have included it to illustrate the points that I have made here. I see now that the subject needed either a quick watercolour sketch or a 3-hour pencil drawing. However, you should not destroy a piece of work just because it could be better, but learn a lesson from the experience.

The watercolour of St Paul's and the City of London from the South Bank (**fig. 62**) took more than 2 hours to paint: the subject was complicated. Using a pocket sketchbox, I began by painting with a Dalon D.88 13 mm (½ in) square-ended brush and drew in the shape of the skyline. I used the brush edge for the narrower shapes. With various neutral colours – Prussian Blue with Burnt Umber, Raw Sienna with a touch of Ivory Black – I built up the shape of the city, working from the skyline down to the line of the River Thames. I left white areas for white buildings or buildings which needed a light colour. The foreground building was painted in Raw Sienna and

Fig. 60

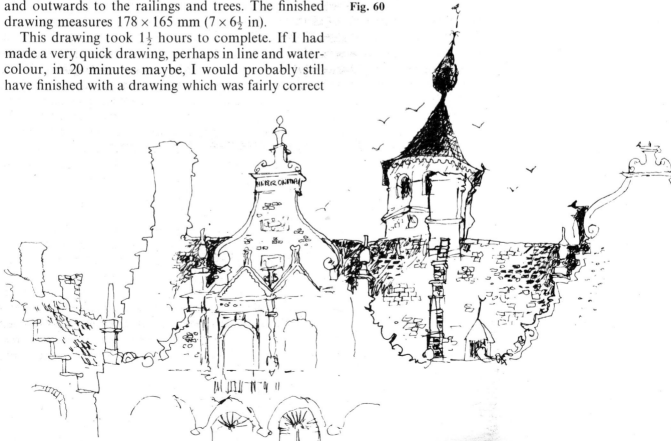

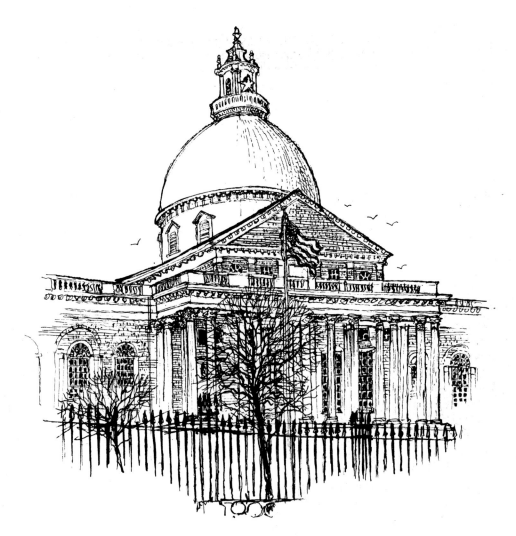

Fig. 61

Burnt Umber. The sky was painted by using the wet-into-wet technique and then blotted. The River Thames was painted with a mixture of Prussian Blue, Crimson Alizarin and a little Ivory Black.

At this stage I drew the whole range of the architecture of the city with a 0.25 technical pen, unifying all the subject matter. This procedure took the longest to do as care was needed to get every building and all the building details in the correct place in relation to each other. I drew quickly to prevent the drawing becoming tight. Then I used colour again, with a Diana Kolinsky No. 6 brush, to paint in the red brick buildings and the bridges, and also to darken the roofs and some of the skyscrapers.

Fig. 62

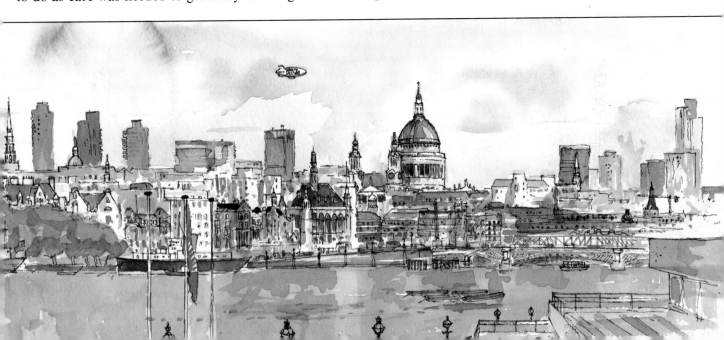

With the sun constantly going in and coming out the play of light over the city was changeable; it was a question of waiting and deciding which shadows on which buildings made the most dramatic effect. Eventually, I decided to float dark shadows over St Paul's, the buildings behind the railway arches and two towers on the right. This technique left the whites standing out. I then added some more pen lines and, with a Diana Kolinsky No. 3 brush, painted in more details on the buildings. Lastly I floated a very pale wash of the river colour into wetted paper on the skyline by St Paul's and on the right by the skyscrapers to create the effect of smog, blotting it out afterwards. This was the moment to decide if the work was finished or whether I should add more detail or colour. I decided it would be superfluous to carry on. The finished painting measures 152×355 mm (6×14 in).

Fig. 63 was painted in the lovely square in Veurne, using the Daler-Rowney miniature box with its accompanying small brush, and a 0.25 technical pen.

The watercolour of Camden Passage in North London (**fig. 64**) is more successful than the drawing of the Old State House because I had a comfortable sketching seat and I knew that I was making a simple working sketch for a larger painting, one of a series of London. As a result, I was uninhibited in my approach, aiming to finish with just enough information to be able to work from in the studio. I also took several photographs but I did not need them. This study, measuring 305×178 mm (12×7 in), was finished in $1\frac{1}{2}$ hours. I used a small watercolour box and two pens, 0.25 and 0.70.

Fig. 63 and (*opposite*) **Fig. 64**

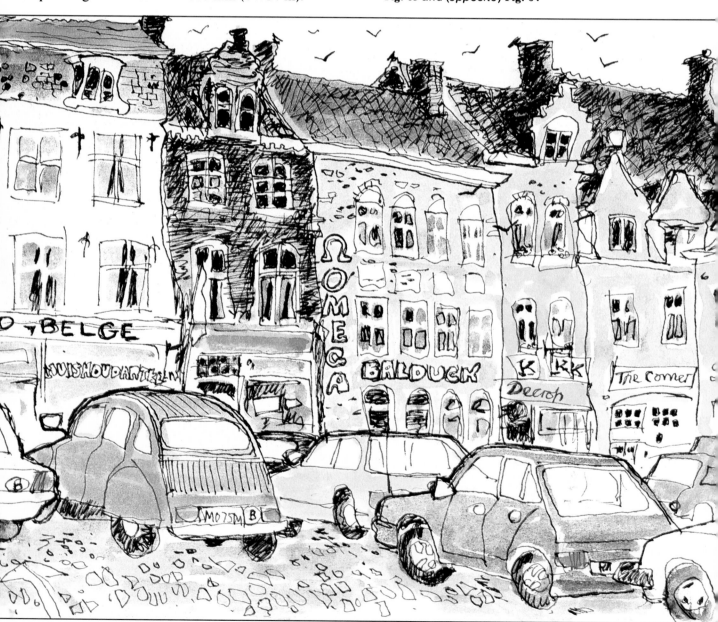

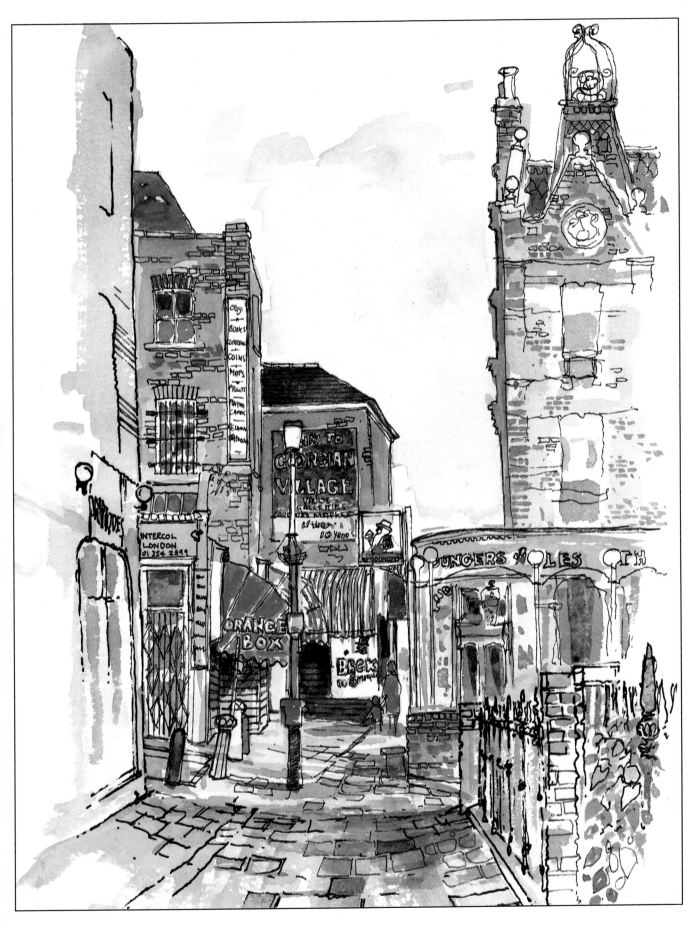

EXERCISE TWO

My idea here was to demonstrate how a complex subject such as this view of New York from Central Park can be treated with simplicity. Often the simpler the approach the more impressive the results.

The pen drawing in **fig. 65** is one of several such sketches I made while I was in the city at the end of March. I was fascinated by these massive buildings seen through the tracery of winter trees. On the day I drew this sketch, although the sun was bright, the temperature was not much above freezing point so I worked quickly. I used this drawing as the basis for the watercolour here, but as you can see I altered the viewpoint slightly when I came to start the painting in order to make a more balanced and harmonized composition.

First stage I used Saunders 140 lb Not watercolour paper for this painting and I started by stretching it on a board. This was done by wetting both sides with a 51 mm (2 in) brush and pasting down the edges with 51 mm (2 in) wide gum strip. I worked from a pen drawing I had made previously on the spot. First I drew in the barest essential detail with a B pencil – just the outline of the city skyline, the rocks in the foreground and a suggestion of the trees. Then I floated in the sky with a Dalon D.77 No. 10 brush. I used Monestial Blue with a touch of Cadmium Yellow and then pressed a clean sheet of blotting paper over the surface. I also floated in a light wash of Yellow Ochre, but leaving some white areas, and blotted it again to give a textural effect. When this was dry, I painted in the main shapes of the skyscrapers. Starting on the left and with a full brush of colour and the No. 10 brush, I carefully painted in to the shape of each building, beginning at the top of each, with Monestial Blue and a little Ivory Black. Again I blotted out, but you will notice that the colour remains stronger in tone in places. The act of washing out or blotting with blotting paper or tissue is one of practice, trial and error. You will need to experiment with the technique before you will be able to judge how to achieve the effect you require. The far building in the background on the left and the rocks in the foreground were painted with Burnt Sienna and Burnt Umber.

Second stage I painted in the dark building in the centre with a Dalon D.77 No. 5 brush, leaving spaces for the windows by painting with vertical and horizontal strokes. Next I suggested the main tree trunks and the shadows on the buildings, using a rather strong mixture of Monestial Blue and a little Burnt Umber, which was then blotted. The skyscraper on the right

was given a light wash of Burnt Umber and the green roof of the other tall skyscraper was touched in with a mixture of Monestial Blue and Yellow Ochre. A wash of Burnt Sienna and Burnt Umber over the ground between the rocks completed this stage.

Finished stage The final stage was a matter of bringing all the elements together. I painted in the windows of the remaining skyscrapers with a Dalon D.77 No. 1 brush. I felt it was better not to be too meticulous; I wanted merely an impression of what I saw. The shadows in the foreground were added with Burnt Sienna. The trees with their tracery of branches made a fine foil for the city behind and the cast shadows of the branches added a decorative quality to the composition. Remember that branches get thinner as they reach the extremities of the tree. I drew carefully, ensuring that each mark on the paper had meaning. Carelessness shows in a painting but this does not mean that every drawing must be meticulous; you must learn to know at what point to stop to prevent overworking. The finished painting measures 165 × 120 mm (6½ × 4¾ in).

Fig. 65 Pen sketch

Fig. 66 First stage

Fig. 67 Second stage

Fig. 68 Finished stage

53

HARBOURS AND SEASIDE

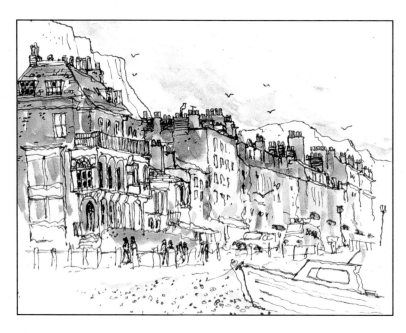

Fig. 69

This is a favourite subject of mine, evocative of earlier sailing days, far horizons, broad beaches, seas and skies of all colours, and above all memories of visits to my favourite cities on the water: Amsterdam, Venice, London, Istanbul, Boston (USA), Leningrad, Bruges, and many others.

The small sketch of Dover in **fig. 69** was drawn in a pocket sketchbook measuring 102 × 152 mm (4 × 6 in) whilst I was waiting for the ferry to Boulogne. It was done quickly, using a 0.25 Faber-Castell pen and then washes of colour, blotted with tissue. I used Burnt Umber, Prussian Blue, Ivory Black, Yellow Ochre and a little Cadmium Red from the Daler-

Rowney small combination watercolour box, and the little brush it contains. When applying washes to a line drawing, put them on quickly and freely – don't try to follow every line. Notice how I kept the chalk cliffs white against the dark roofs, making the sky dark as well to accentuate their whiteness even more. I think this sketch came off particularly well because I had only 30 minutes in which to finish it!

Fig. 70, a small watercolour and line drawing of the beach and town of St Malo, France, was drawn in a sketchbook, working across two pages, and measures 57 × 203 mm ($2\frac{1}{4}$ × 8 in). To paint across the full width of a sketchbook in this way is a habit of mine;

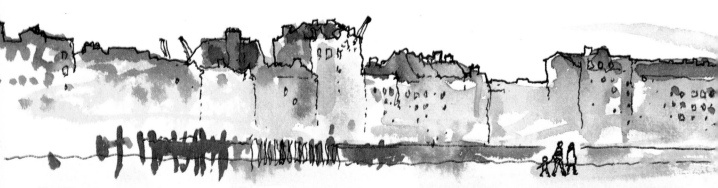

Fig. 70

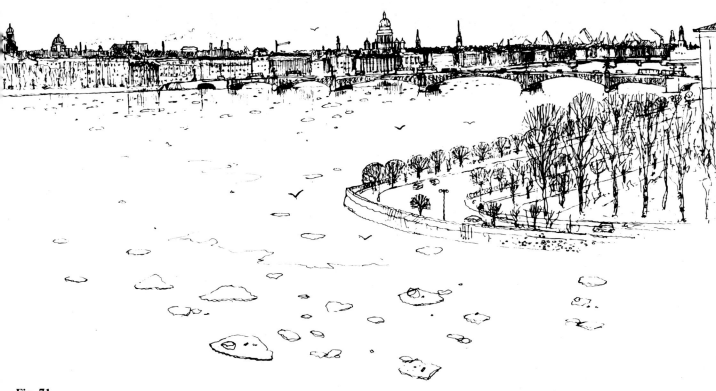

Fig. 71

it gives me double the space. I used Brown Madder Alizarin, Ivory Black and Raw Sienna for the colour washes and then put in the line work with a 0.25 technical pen. The drawing was sketched in about 20 minutes.

The technical pen drawing of Leningrad illustrated in **fig. 71** was drawn from a high-up bedroom window, looking across the vast River Neva with its ice floes floating downriver. It took 1½ hours and measures 127 × 292 mm (5 × 11½ in). It is not possible to include all that you see in such a subject; much of the detail in the far buildings can only be suggested. The skyline, however, must be shown accurately because it is by

drawing across this from left to right that the whole composition is established. Imaginary lines can be dropped vertically downward to fix the position of the bridge arches and each prominent building along the river. Normally the darkest tones in a drawing or painting are those nearest to the viewer, but in this case I made the skyline dark so that the towers, the cathedral and the white or light-coloured buildings on the river would stand out. You will notice that buildings by water often seem larger than life and the reason for this is twofold: they tend to be tall, and they are invariably viewed over water and so stand unobstructed by foreground details.

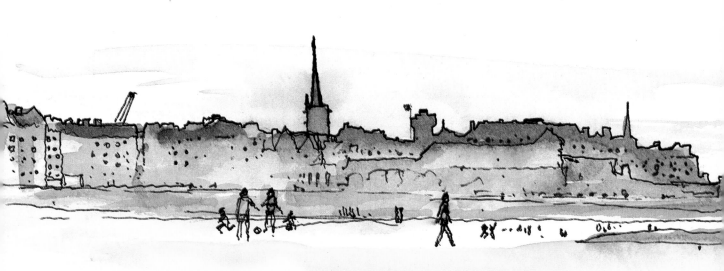

The painting of the sea at Aldeburgh in Suffolk (**fig. 72**) is a departure from the other watercolours in this book and is included for that reason. The beach at Aldeburgh is of shingle and dips sharply, so that if you stand near to the sea the ground floors of the houses along the seafront are lost behind the bank. It was this unusual aspect that inspired me to paint this subject. The houses themselves are not especially old – mostly Victorian and Edwardian – and not historically of any great note. However, proud owners have looked after them and decorated them with bright, lively colours and the whole front therefore has unity although the houses are of contrasting styles.

Fig. 72

First of all I made some pencil and ink sketches and took a number of photographs of adjacent houses along the front. A painting from where I stood would have been impossible, standing on tiptoe most of the time to see all I wanted. Then I made a photo montage by gumming my photographs together in sequence to make a panorama. This is a helpful ploy I have used for many years: by making a long picture in this way I can more easily select which area I want to paint. Once I have decided this, I then make a key line drawing of it.

I was then ready to start the painting. I stretched a sheet of Bockingford 140 lb watercolour paper and made a very careful and almost mechanical pencil drawing with every detail shown. To help your free-

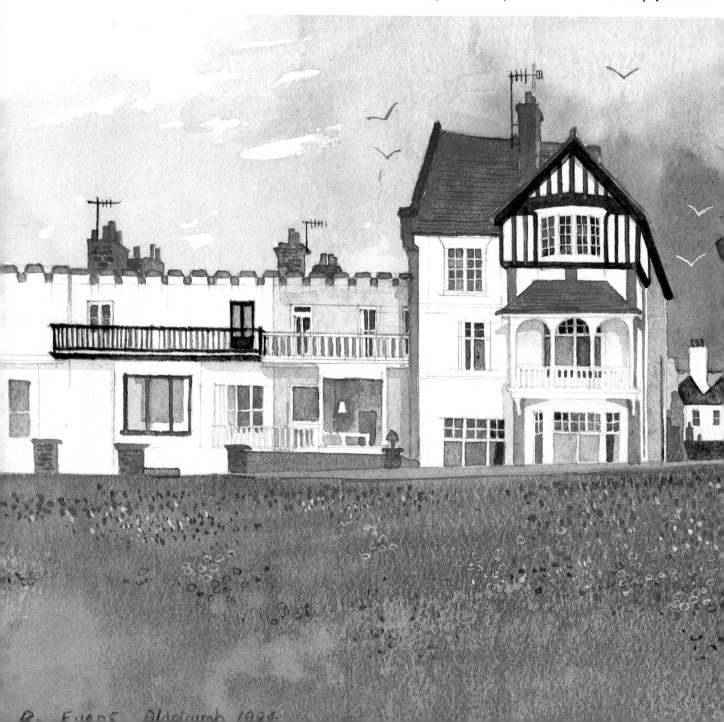

hand drawing you can if you like use a set square and a T-square to put in some guidelines lightly in pencil, making a grid.

I painted the sky first by floating in some water and then, when this wash was almost dry, painting in a dark grey wash of Payne's Grey, Prussian Blue and Ivory Black. I allowed this to almost dry and then washed it out. A dark sky was necessary, especially in the centre of the painting, as a contrast to the white and near-white houses.

The painting of the houses was a deliberately painstaking process. I wanted the windows and verandahs with their shadows to be carefully detailed because the patterns made by them were what especially interested me. The shadows under the eaves and verandahs were particularly important. I used a No. 1 brush to darken some of the windows which were in shadow.

To finish I made the dark roofs even darker to heighten the contrast. The foreground beach, which I had painted with Brown Madder Alizarin and Raw Umber, was at this stage too red and too light, so I shaded the whole area to contrast with the houses in sunlight and to balance the dark sky behind them. I did this with a strong wash of Prussian Blue and Ivory Black, washing out only when it was all but dry. I then picked out a few pebbles with gouache white and Brown Madder Alizarin. The white and dark seagulls, carefully placed, finished the picture. This detailed painting, measuring 165×355 mm ($6\frac{1}{2} \times 14$ in), took 8 to 10 hours to complete.

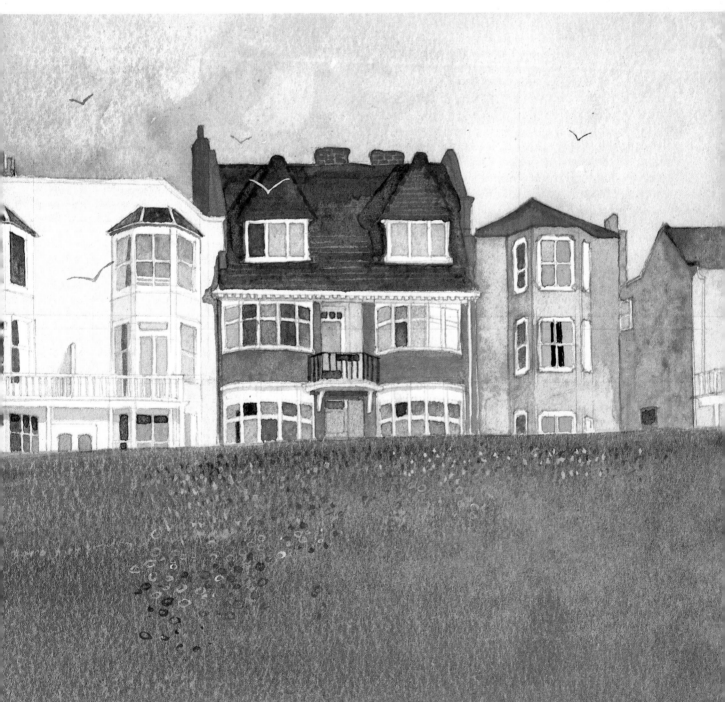

EXERCISE THREE

This watercolour of Weymouth harbour in Dorset was sketched on the spot in 2½ hours on a sunny morning, with an additional 30 minutes' work in the studio afterwards. I was struck by the bank of buildings across the quay. The skyline in particular was interesting – a prime consideration when choosing a subject.

First stage I started by drawing on Saunders 140 lb Not watercolour paper with a B pencil for 2 hours – I needed this amount of time to work out the complicated arrangement of buildings. I kept the point of the pencil long and sharp throughout. Then I used the Daler-Rowney miniature watercolour box containing twelve quarter pans and an integral water pot. The lid held the water. I filled in the whole subject from the skyline downward with a wash of clean water, using a Dalon D.77 19 mm (¾ in) wash brush. The colour, a mixture of French Ultramarine and Light Red, was then dropped into the damp paper. Notice how the colour is stronger at the skyline where the paper was already drying. This suited my intention, which was to create the mass of the subject. The houses below the lower roofline and most of the windows were left white, but the quayside and water were also washed in, using a Diana Kolinsky No. 6 brush. Next I blotted out, not wanting this colour to dominate.

Second stage Now I was ready to begin painting in the details. I painted the red houses in the centre background using Light Red and a little Cadmium Red and blotting. Again I left the windows white. The public house on the far left was painted with the same colours, and the brick houses on the right were done with a mixture of Burnt Sienna and Yellow Ochre. I used a mixture of Prussian Blue and a little Ivory Black for the darker roofs, blotting where the colour was too strong. Remember that colours tend to dry lighter so it is advisable to paint slightly darker or stronger than you may think is needed. I then began to paint in some of the detail, such as the ladder, the cars, the boat, windows and roof tiles. I also washed in Burnt Sienna and a little Ivory Black over the harbour wall.

Finished stage The picture was gradually finished piece by piece, darkening or strengthening where necessary and adding the real telling point of the subject – the fine work: the windows, figures, cars and boat, etc. – using a Diana Kolinsky No. 1 brush. After wetting the sky area, I floated in a sky of Prussian Blue with a touch of Burnt Umber. A wash of the same colour was used to paint in the shadows, some of which were over the faces of the buildings to create the

Fig. 73 First stage

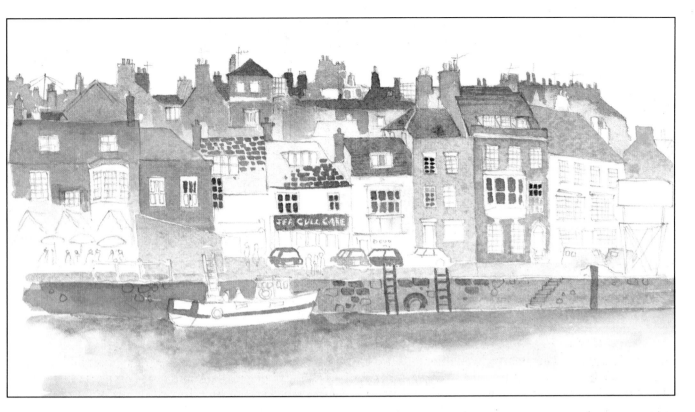

appearance of dappled sunlight, and this colour was blotted when half dry. Some white paper was left as a contrast to the dark windows. I then sharpened the colours and drawing on the boat and at this stage the basic painting was complete. However, when I was back in my studio I darkened some of the windows and figures and cleaned up some of the details. Quite an amount of finishing work such as this can be carried out in the studio, provided enough detail has been drawn in on the site.

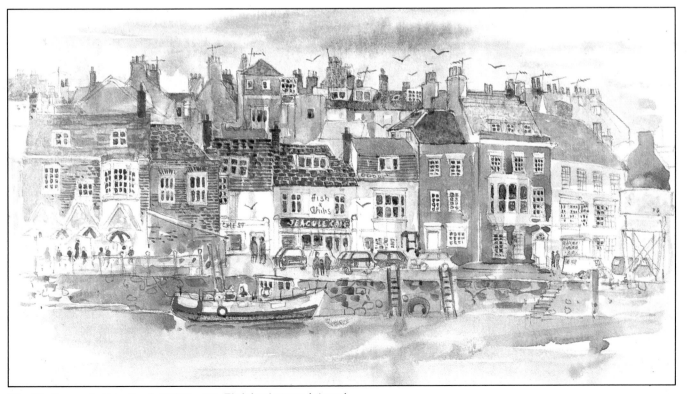

Fig. 74 Second stage (*top*) and **Fig. 75** Finished stage (*above*)

DETAILS

'Oh, it's a mere detail,' many people say, yet it is detail in drawing that supplies the finishing touch. Composition, perspective and scale are all important and the original inspiration behind your drawing is more important still, but correct observation of detail, the way you dot the Is and cross the Ts, can make or mar your drawing.

It is not necessary to put all the details you can see into a drawing; often the merest suggestion of, say, a dark chimney and part of a roof or gable against the sky can be very expressive. The actual shape of that chimney is a detail in itself and although individual bricks or tiles may not be indicated, the fact that it is brick built will show in details such as a serrated edge caused by the mortar having fallen out in places.

Fig. 76 shows a page from my sketchbook and is a good example of the kind of drawing you should use

a sketchbook for – a means of recording information. This sketch of a Victorian terrace was made in preparation for a book jacket I had to design on Victorian houses and is self-explanatory. It measures 140×216 mm ($5\frac{1}{2} \times 8\frac{1}{2}$ in).

It is an excellent idea to keep one sketchbook specifically for details, such as those illustrated opposite (**fig. 77**). These are details of buildings which I find particularly important. Whenever making a serious study of a building remember to look closely at various details: the windows, sash or casement; the brickwork and the method of coursing; the roof tiles or slates; and any other features which particularly catch your eye. Make a note of them in your sketchbook – this will help you to observe them accurately and you never know when they may come in handy as a source of reference.

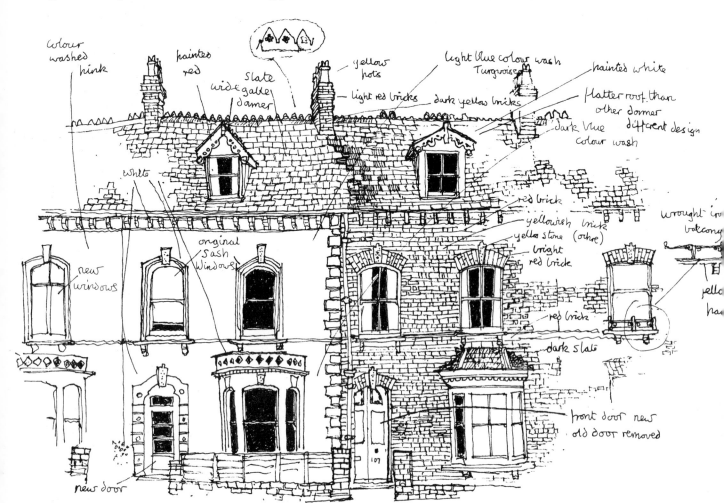

Fig. 76 Sketchbook drawing of a Victorian terrace

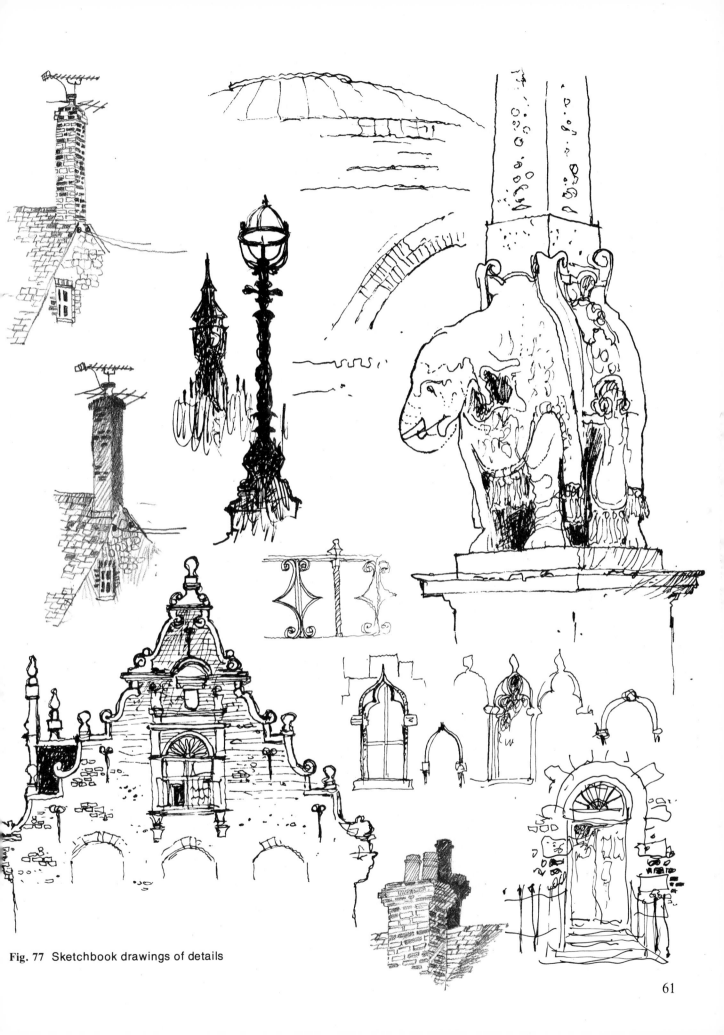

Fig. 77 Sketchbook drawings of details

61

HOUSE PORTRAITS

Many people like to have a drawing of their home – a house portrait – and these can be quite a challenge for an artist. Like portraits of people, they are not easy because owners have some odd ideas about how their houses should look! For example, you may be asked to paint a house in February but represent it as if it were June or July, with flowers around the building. Sometimes it is possible to paint a watercolour or two of a house at different angles there and then, but if a larger and more detailed painting is required, you will need to make watercolour sketches and perhaps take some photographs, and then complete the commission in your studio. Occasionally the owner may want to have both the sketch and the painting.

The watercolour illustrated in **fig. 78** was painted in a large sketchbook across two pages. Measuring 229 ×

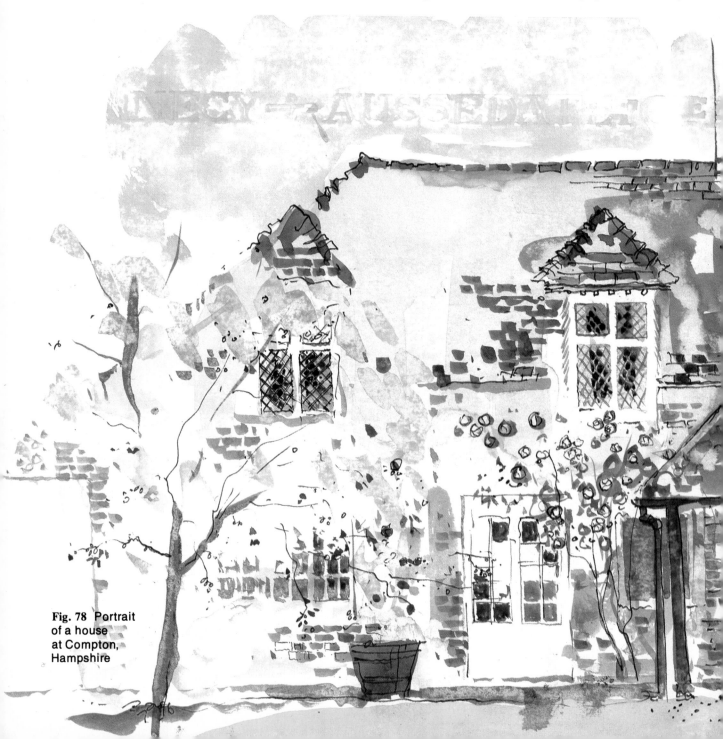

Fig. 78 Portrait of a house at Compton, Hampshire

508 mm (9 × 20 in) and taking about 2 hours to complete, it is the study for a watercolour subsequently painted in the studio. I used Prussian Blue, Ivory Black, Brown Madder Alizarin, Raw Sienna, Burnt Sienna and Sepia, together with a pen and ink. I washed out the roof and sky to create texture. As well as making the sketch shown here, I also drew a few separate details. In addition, I took several photographs, including some close-ups of the roses and the flint and brick walls, and made notes at the side of the sketchbook. These clarify the mind and jolt the memory when working from the sketch later.

This sketch is very lively and the problem was to keep that quality of liveliness in the finished product.

This was of necessity more formal but I like to think that it retained some of the freshness of the sketch.

Letterheadings and personal cards

An attractive way of using your drawings is as letterheadings or for personal and business cards. Such drawings provide a good lesson in extracting the salient points and essence of a building, although in some cases you may decide to illustrate just a part of it: for instance, someone who lives in a house with a beautiful Georgian doorway could use a decorative drawing of that on a letterheading. Whatever you choose, however, you will have to observe and draw it

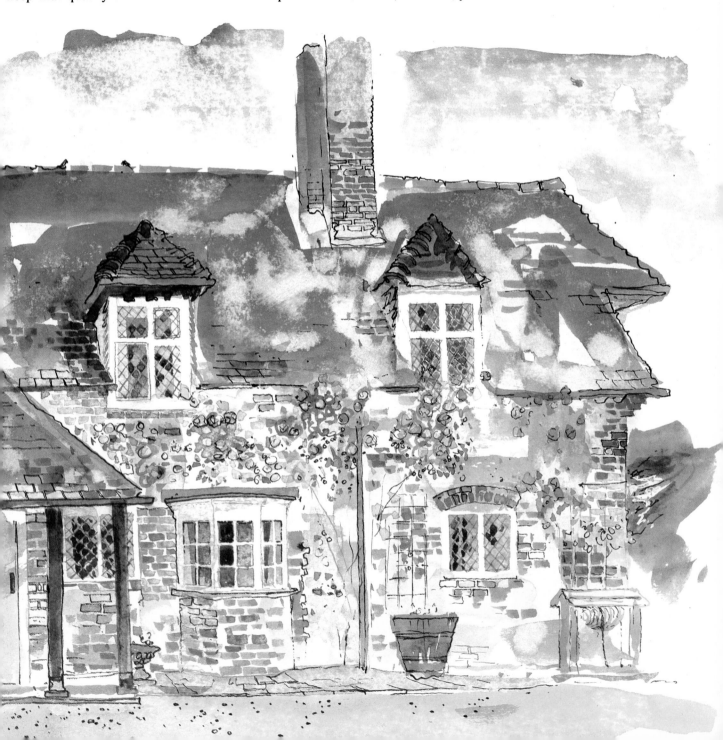

very carefully in order to portray the character of the building in a simple, concise way.

The drawings in **fig. 79** were made with this purpose in mind for they are all suitable for some reduction in size. I have suggested how they can be made both decorative and simplified. They are portraits of actual houses and were drawn freehand, although drawing instruments such as a set square or T-square can be used for this type of illustration. None of them measures more than about 114×114 mm ($4\frac{1}{2} \times 4\frac{1}{2}$ in) in size.

Fig. 79 House portraits suitable for letterheadings